Chip Carving
Pennsylvania Dutch Designs

Pam Gresham

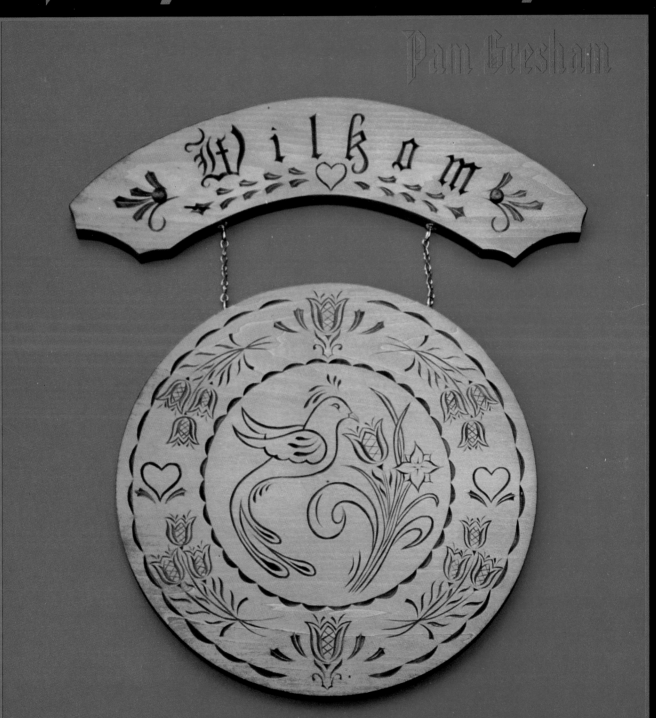

Text written with and photography
by Douglas Congdon-Martin

Schiffer Publishing Ltd

77 Lower Valley Road, Atglen, PA 19310

DEDICATION

I dedicate this book to my son, Kyle.

ACKNOWLEDGMENTS

I have to give special thanks to my husband, Peter. My carvings only enhance his already wonderful pieces. The quality of his craftsmanship is unsurpassable. He built the beautiful Bible Box shown in this book after seeing the original antique while visiting in Pennsylvania. The box itself was truly a work of art. He builds every piece, from the smallest to the largest, with care and precision.

I must thank my brother-in-law, Richard Price. He also builds many of my pieces. He designed the spoon holder, broom holder, and scissors holder pictured in this book. His ideas are fresh and innovative. He has helped me immensely throughout many years.

I would also like to thank my family and friends for all of their help through each of my projects.

I must thank Douglas Congdon-Martin for his help in writing each of my books. He is a pleasure to work with.

I would also like to thank Peter and Nancy Schiffer and all the wonderful people at Schiffer Publishing. It is truly a special place filled with special people.

Copyright © 1995 by Pam Gresham

Library of Congress Cataloging-in-Publication Data

Gresham, Pam.
 Chip carving Pennsylvania Dutch designs/Pam Gresham.
text written with and photography by Douglas Congdon-Martin.
 p. cm.
 ISBN 0-88740-711-0 (soft)
 1. Wood-carving--Patterns. 2. Folk art, Pennsylvania
Dutch. 3. Decorative arts, Pennsylvania Dutch. I. Congdon-
Martin, Douglas. II. title.
TT199.7.G77 1995
736'.4--dc20 95-5476
 CIP

Printed in China.
ISBN: 0-88740-711-0

Published by Schiffer Publishing, Ltd.
77 Lower Valley Road
Atglen, PA 19310
Please write for a free catalog.
This book may be purchased from the publisher.
Please include $2.95 postage.
Try your bookstore first.

We are interested in hearing from authors
with book ideas on related subjects.

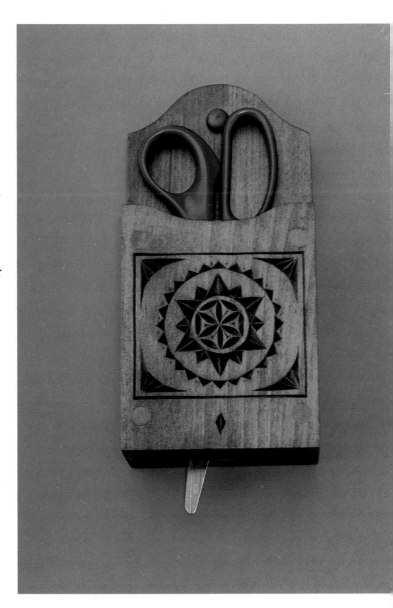

PREFACE

The folk art of the Pennsylvania Dutch is charming, delightful, and intriguing. Their traditional designs and symbols are usually meant to bring good luck, worship God, or invite friends to the home. These designs and symbols are traditionally found painted on barns and pottery, either painted or carved on furniture and various household items, and carved into butter and cookie molds. Their religious documents, such as baptismal and birth certificates, are filled with beautiful, tranquil designs, and ornate lettering.

I love to travel to southeastern Pennsylvania to see the beautiful folk art that enriches the area. There are wonderful hex signs painted on the great barns throughout the land. Every menu, tourist map, and sign has Pennsylvania Dutch folk art enhancing it. The trip would not be complete without a visit to both Jacob Zook's and Will Char's hex sign shops. Both are located in Paradise, Pennsylvania.

On my travels to Pennsylvania I purchased many books about the Pennsylvania Dutch. I also found several books at my local library. Over the years I have adapted many of their designs to chip carving. There is magic in a design that has tradition and meaning associated with it.

In this book is a pattern for each piece pictured, and the layout process required to make the pattern fit the size of the reader's piece. For each pattern I relate to the reader the meaning of the particular design as I have come to know it through my research.

My first book, *Basic Chip Carving with Pam Gresham,* gave extensive explanations of each cut. This book, *Chip Carving Pennsylvania Dutch Designs,* takes for granted that the reader has some knowledge of the techniques required to chip carve, though some of the elementary steps are reviewed.

Carve these traditional Pennsylvania Dutch designs and bring a little magic to your chip carvings.

CONTENTS

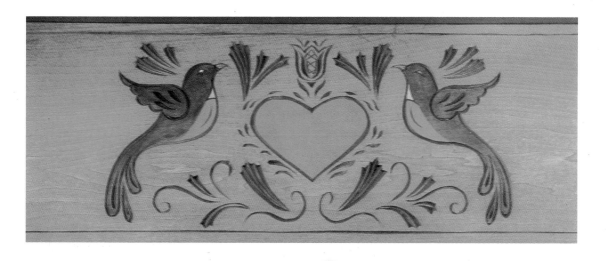

INTRODUCTION

In the beautiful rolling hills of southeastern Pennsylvania lives a quiet, religious people known as the Pennsylvania Dutch. They came to America seeking the religious freedom promised by William Penn. Their first ship landed in 1683, and they came in great numbers for almost a century.

Many emigrated from southern Germany and the Rhine Valley. Others came from Sweden, Switzerland, Bavaria, France, and Holland. They included the Amish, Mennonites, Dutch Quakers, Lutheran, Reformed, and French Huguenots, as well as others. They were called "Deutsche" (German) because the Germans were the most numerous among them. With time the pronunciation became "Dutch" as in Pennsylvania Dutch. According to the book *The Pennsylvania Dutch and Their Furniture,* "they arrived in such great numbers that Benjamin Franklin once worried aloud that Pennsylvania would soon become a German colony."

Pennsylvania was a rich forest land at this time. These people did not have much when they arrived in their new land. They made almost everything they needed from wood, which was the raw material in greatest supply. Many wooden items were decorated with a carved design. Incised designs were carved into butter and cookie molds, spoon racks, boxes, and chests. The carving was usually done with a simple penknife. Carving was a popular way of passing time and relaxing among the early settlers, but seemed to disappear in the mid-1800s.

Early examples of the carving of the Pennsylvania Dutch show motifs of tulips, flowers, geometric radials, and hearts. Butter molds which have lasted through the years, show these to be the most traditional designs. Birds are seen on much of the folk art painted on hex signs, furniture, pottery, and religious certificates.

Traditional designs found in Pennsylvania Dutch folk art seem to be symbolic. Through my research I have found varying opinions on the meanings of the designs. Some experts believe the designs are symbolic, while others believe they are strictly decorative. These beliefs probably relate to the various religions among the vast group of people known as Pennsylvania Dutch. I include in this book the known traditional meaning for each design.

This book is about chip carving. I do not discuss specific woodworking details. There are many woodworking books, magazines, and shows that deal with that subject. The limited space within this book needs to deal with aspects of chip carving. I do give measurements for some pieces, and I hope that is sufficient for most woodworkers. These designs can and should be adapted to your pieces.

You may need to size the drawings for your piece on a copy machine by either enlarging or reducing the pattern. Do not be afraid to mix and match the designs. Change the borders and combine different patterns. There are numerous possibilities contained within this book.

Remember to select and prepare your wood carefully before putting the pattern onto the piece. I recommend basswood for chip carving. Remember the rule, the whiter and lighter the wood, the easier carving it will prove to be.

Be sure to sand your piece thoroughly before putting the pattern onto it. Always sand with the grain. Some gentle hand sanding may be required after carving, but only to remove any stubborn pencil marks. Be careful not to sand over any sharp edges because this dulls them and takes the crisp, clean look from the carving. Pieces also tend to break out easily at this point.

Since the publication of my first book, many people have called and asked me what I use to finish my pieces. I have to be honest with them as I do with you here. My husband, Peter, is also a professional carver. He was professional long before I was. He carves in-the-round and relief carvings. He developed the stain we use now for his carvings. Pete spent many hours mixing different chemicals, applying the mixtures to small pieces of basswood, then numbering and timing each. From these experiments, and years of trial and error, he developed beautiful stains. There are no commercial products that compare in color quality and do not blotch on basswood. My point in telling this to you, the reader, is that I promised my husband before writing *Basic Chip Carving* that I would not tell the staining mixtures and processes we use. We still make our living by selling our carved products. We feel that our stains and finishes are part of what sets our work apart from the work of other carvers. There has been such a positive response to our stains that we are looking into selling them to the public. Please accept my honesty and sincerity on this matter. My intentions are to write the best books on design and techniques for chip carvers. Finishing techniques could be another complete book. There are several books dealing with that subject.

For those of you not familiar with my first book, *Basic Chip Carving with Pam Gresham*, it is a detailed book on the tools and techniques of chip carving. Included in that book is a detailed tool list for drawing and carving, discussions of knife sharpening techniques, knife positions, how to select and prepare the wood, and basic geometric concepts. It explains at length the technique used to execute each type of cut used in chip carving. The book examines chip carving from the easiest to the hardest cuts.

If you need a detailed description of any of the following cuts please refer to that book. This book is the second in a series that will focus on various design motifs for chip carvers. The first was *Chip Carving the Southwest with Pam Gresham*. Both books are natural progressions from the original book.

These designs are special to me. I trust you will enjoy carving them as much as I do. Pieces enhanced by these designs make wonderful and special gifts for family and friends.

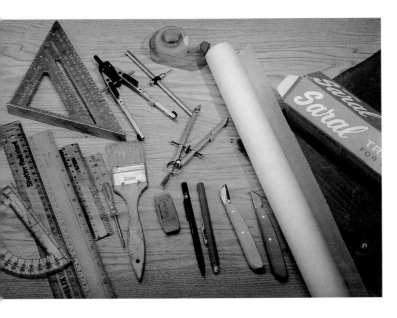

The tools for chip carving are simple. They involve several measuring and layout tools, pencils, erasers, and, of course, knives.

In Position 2 the knife is held with the blade facing away from you. The thumb is on the back of the knife with a little tip of the thumb (1/2") on the back of the blade. Wrap the rest of you fingers around the knife handle. The cut is away from the body.

The basic knife positions require some practice to perfect. Throughout the book we refer to Position 1 and Position 2. This is Position 1. You grasp the handle firmly with the blade facing you. The middle joint of your index finger should be where the back of the blade meets the handle. Keep the hand completely on the wood. The placement of the thumb is the tricky part, and the hardest to endure while learning. It is necessary to learn this correctly because it will keep you from slicing your thumb.

The inside joint of the thumb should be at the very end of the wooden handle. The blade of the knife will almost be on your thumb. Bend the thumb slightly backward at the middle joint, and place the tip of the thumb on the board. The thumb and the knife will always move together as you cut.

Occasionally you will use a stab knife to create decorative cut. This knife does no cutting. You grasp the knife firmly with the beveled edge of the blade toward you. Press down firmly at the point where the cut begins...

and rock the knife back toward you. Return the knife to vertical and take it out. With these three basic knife techniques almost all of chip carving can be done.

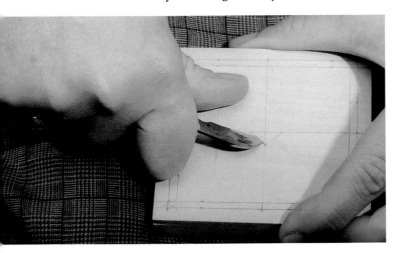

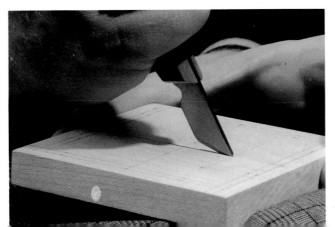

THE HISTORY AND MEANINGS OF PENNSYLVANIA DUTCH DESIGN

Because of my fascination with these designs, over the years I have found myself collecting every book and piece of information I could find on this subject. I believe my curiosity was aroused several years ago when a friend, who collects and carves cookie molds, asked me to chip carve a special ornamental mold. This friend had been stationed in several places overseas during his career in the military. He explained that the carved designs of many cookie and butter molds had meanings associated them. The stories and meanings of his cookie mold collection fascinated me. Since then I decided that I needed to learn more, adapt these designs to my carvings, and help keep the traditions alive.

Though the first Pennsylvania Dutch symbol that comes to people's minds is the hex sign, they are not universal. Among the Pennsylvania Dutch people, the Amish and the Mennonites do not have "hex signs" painted on their great barns. These symbols are found on the barns and household items of the Lutherans, Reformed, and other church people.

Usually these signs are brightly painted, but I chose to adapt them strictly for carving. There are many more designs in existence than I could possibly show in one book. I chose the ones I use in my own work and that my friends and customers seem to love. The meanings and symbols I adapted for chip carving, and now share with you, are among the most popular in Pennsylvania Dutch folk art.

Please remember that the patterns in this book are my adaptations designed to be chip carved. There is such a resurgence in chip carving today that I thought it would be interesting if I shared with you some of the styles I explored over several years. I started carving designs with meanings as gifts for family and friends. I was astonished at the interest they received from people who saw and understood them.

As I stated in a previous book, I believe it is important to preserve and use the traditions of differing cultures. Our understanding of the folk art of a culture may not be as precise and deep as its people would like. Knowing that there is more to cultural traditions than can be learned in the limited amount of time available to study them, helps us realize their richness and complexity. I hope this book will increase awareness of the origins and meanings of the Pennsylvania Dutch folk art, and add an extra dimensions to your pieces.

The Tulip

The tulip is the motif that appears most often on hand made butter prints, according to *Butter Prints and Molds* by Paul E. Kindig, (Schiffer Publishing, 1986). "This is not surprising as Pennsylvania farmers were the largest producers of print butter, and the tulip was the most popular motif on Pennsylvania pottery and other decorated items of that culture."

The word tulip comes from the Turkish word "tulbend," which means lily. The tulip was introduced into Vienna from Turkey in 1554, and has been used in European folk art ever since. The question is: since the tulip comes from the lily family, and the lily is a often-used religious symbol, is the tulip used as a religious symbol or a secular decoration? Frances Lichten states that "...many of these German colonists were guided by a mystical form of religious belief, and in the mystical approach to religion the tulip stands for the lily: a symbol of man's search of God, and a promise of bliss in Paradise." (*Butter Prints and Molds*) But the answer to the question may be that the tulip was used for both its religious significance and because it is such a beautiful and colorful flower. Through my travels to Pennsylvania, I know that the Pennsylvania Dutch people love to plant and grow beautiful flowers and vegetables. It is their way of life.

The tulip is often seen in groups of three. These stand for faith, hope, and charity, or faith in yourself, faith in what you do, and faith in your fellow man. Another interpretation is that they stand for faith, goodwill, and peace. Finally, some see the three tulips as standing for the Holy Trinity.

Birds

The birds seen on my pieces in this book are my adaptations of the Pennsylvania Dutch "Distlefinks." These birds are found in many different forms throughout the folk art of these people. In his book, *The Art and Meaning of the Pennsylvania Dutch Hex Symbols* (Triangle Printing Co., 1964), J.E. Herrera, A.B., B.D.M.S.M, hexologist, says that these birds are extremely popular in hex signs. "Actually a Goldfinch, this bird has the distinction of being called a Distlefink because of its great desire to feed on 'thistle seed' and use thistle 'down' for its nest.

This sign appears among the earliest drawing of the Pennsylvania Germans and has been variously colored. The bird stands for 'Good luck or good fortune'...The Dutch expression 'Distlefink' means 'thistlefinch.'" The standard meaning of a distlefink seems to be "good luck and happiness." When two distlefinks are drawn together they mean double good luck and double happiness.

Hearts

Hearts are another motif found in great numbers in the folk art of the Pennsylvania Dutch. Frances Lichten is quoted as saying that the heart symbol "is religious in significance, and in symbolic interpretations of folk art it represents the heart of God, the source of all love and hope of a future life. Only after the Victorian romantic period arrived did the Pennsylvania Germans adapt the heart as a sentimental symbol." (*Butter Prints and Molds*) Hearts were used in such great quantities that not all would have held such religious meaning, but no one really knows the origin. The meaning for the heart in most reference books is simply "love."

Scalloped Edges

These are found around the circles on the "Wilkom" sign and the bible box. The scallops denote waves on the ocean for smooth sailing through life.

Fractur Lettering

The lettering used in this book is adapted for chip carving from the traditional lettering known as "fractur." I did extensive research on the lettering used on the bible box. The best explanation I found for the style came from Jacob Zook, in his book *The Most Asked Questions about the Pennsylvania Dutch Country and the Amish* (Jacob Zook, 1988). "Fractur writing was inspired by the illuminated manuscripts of the middle ages. The Pennsylvania Dutch fracturs were pen drawings. The folk artist, usually the schoolmaster or preacher, combined washes of colors in traditional motifs of tulip, heart, distlefink, and angel with elaborately scrolled lettering inked with a goose quill." Fractur was used on significant documents such as birth, baptismal, and marriage certificates.

Meanings of Symbols Used with Pieces in this Book

Wilkom Sign

Three tulips, distlefink, hearts, scalloped edges, and fractur lettering.

Bible Box

Tulip, hearts, scalloped edges, fractur lettering, and six-sided rosettes.

The six-sided rosette is one of the oldest known religious symbols. It is found in many old churches in the windows, painted on the walls, and cut into stone. I have not found it written, but have been told that it is the symbol of the "good Christian faith."

I used this symbol in the corners of the lid and made the grid on the side of the box from this symbol. I wanted the design of this box to be filled with religious significance.

Spoon Holder

This twelve petal rosette means "may each month of the year be a joyous one."

Scissor Holder

I do not know the meaning of this design. I saw it on a piece from the right time period and area to be Pennsylvania Dutch design. I thought it was a nice geometric to give to you.

Shelf, Broom Holder, and Friends Forever Plaque

These pieces incorporate adaptations of the Pennsylvania Dutch friendship birds, hearts and tulips.

THE PATTERNS

Some patterns have dots for you to add the connecting lines to. I draw some patterns this way because they will last longer and be more precise. I also do it because I draw the patterns in ink for my books and it is difficult to precisely draw and show exact connections of small lines in ink. I always draw some lines that way on my own patterns, and have done so for years. I feel it works much better in creating a precise drawing.

Compass marks show the compass adjustment from the center out.

CORNER DESIGN for:
 Refrigerator magnet and scissor holder. Position corners 1/8" in from straight line borders.

SCISSOR HOLDER DESIGN
 Use with corner design.

Compass Mark

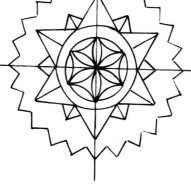

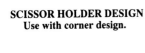

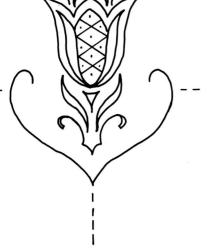

REFRIGERATOR MAGNET
 Overall size–3-1/2" x 3-1/2". Straight line border is 1/4" from edge. Center this design. Use with corner design.

Enlarge patterns 127% for original size.

Grain

Width

Compass Marks

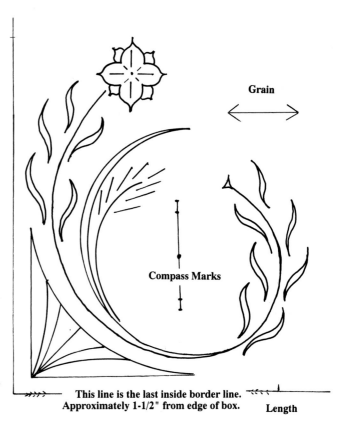

This line is the last inside border line. Approximately 1-1/2" from edge of box.

Length

BIBLE BOX LID–CORNER DESIGN
 Position by matching inside border line with the outside line of this pattern.

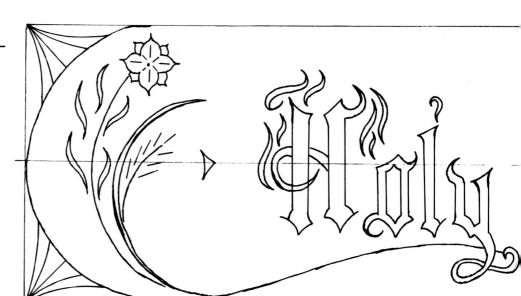

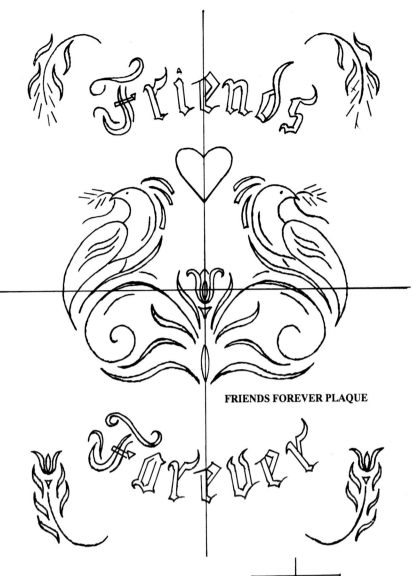

FRIENDS FOREVER PLAQUE

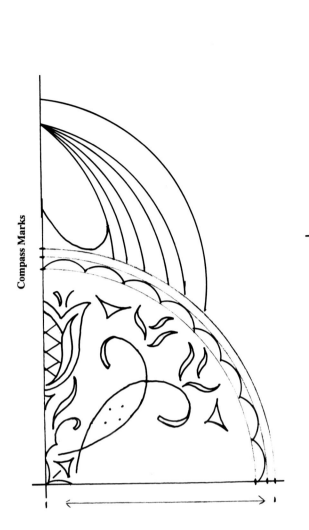

Compass Marks

BIBLE BOX LID–CENTER DESIGN
 This drawing is 1/4 of the design. To complete the design flip this section over–match lines and trace. Continue flipping and tracing until design is completed.
 Note: Overall lide size is: 19" x 14"

Overall size of original pattern is 1-1/2" x 1-3/8".

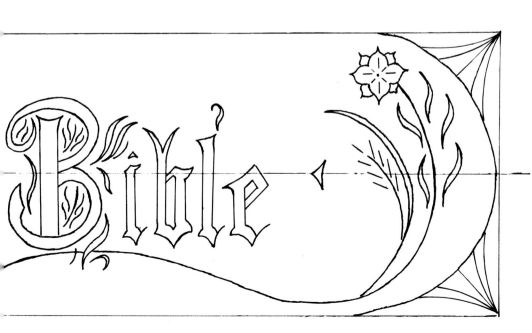

BROOM HOLDER
 Flip pattern over and trace for opposite side.

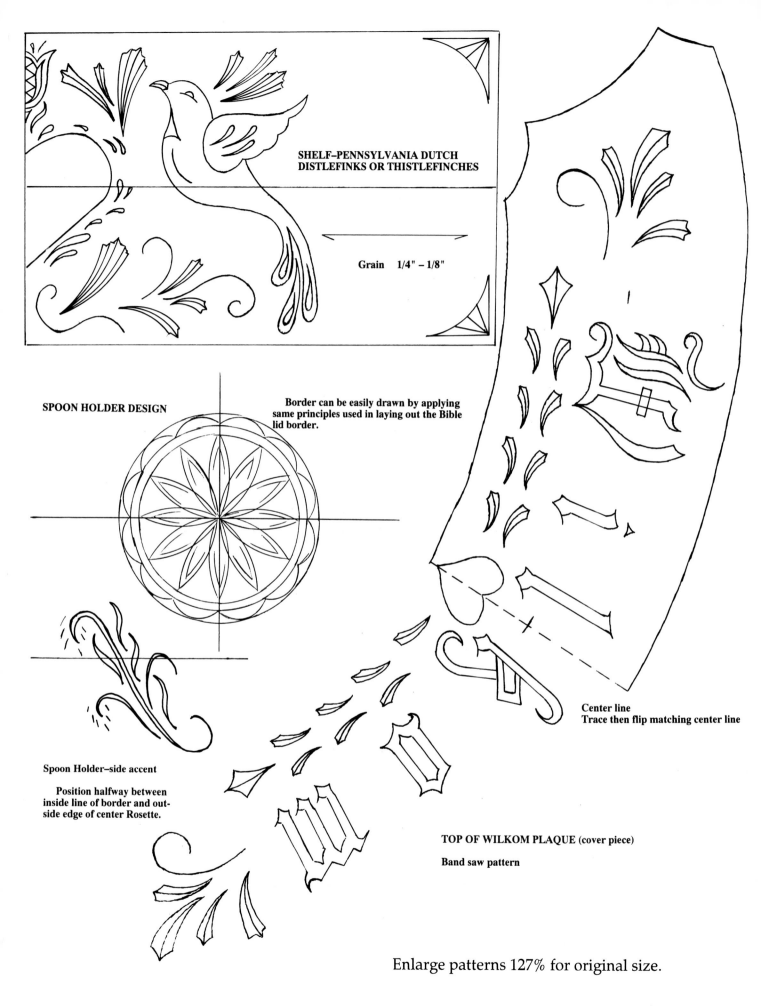

SHELF–PENNSYLVANIA DUTCH
DISTLEFINKS OR THISTLEFINCHES

Grain 1/4" – 1/8"

SPOON HOLDER DESIGN

Border can be easily drawn by applying
same principles used in laying out the Bible
lid border.

Spoon Holder–side accent

Position halfway between
inside line of border and out-
side edge of center Rosette.

Center line
Trace then flip matching center line

TOP OF WILKOM PLAQUE (cover piece)

Band saw pattern

Enlarge patterns 127% for original size.

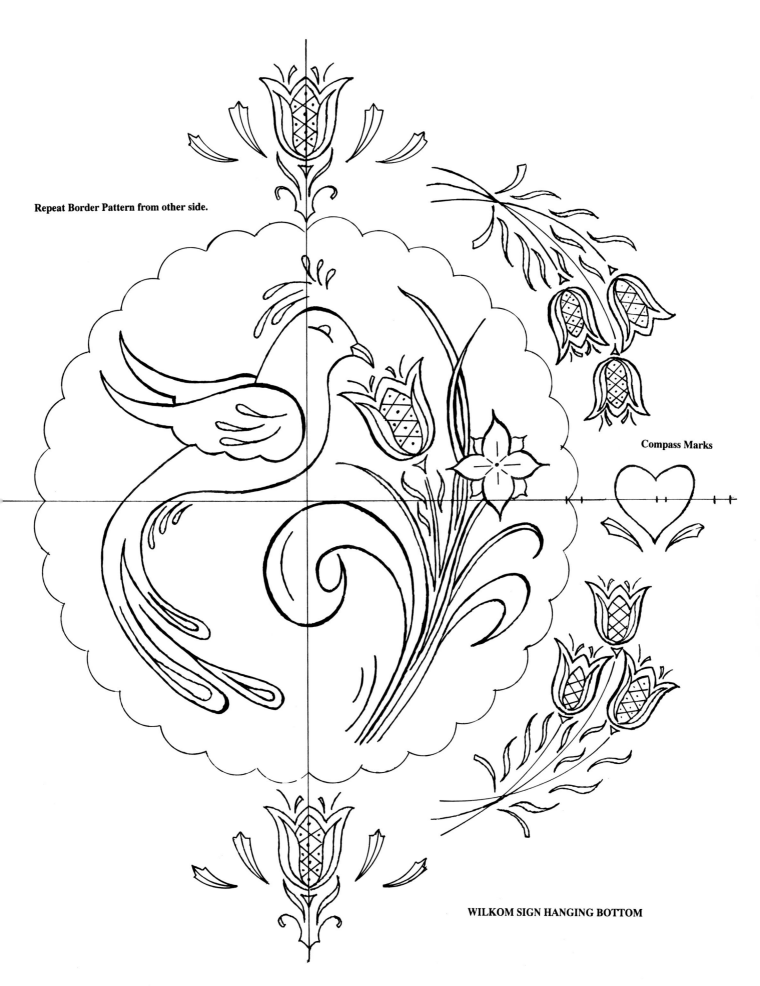

Repeat Border Pattern from other side.

Compass Marks

WILKOM SIGN HANGING BOTTOM

11

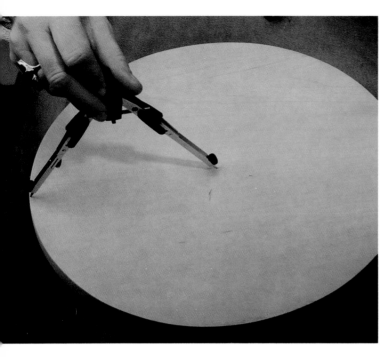

Begin the Wilkom plaque by measuring from all sides of the plate to find the center.

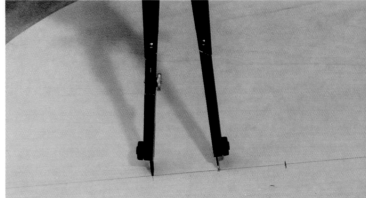

Use the compass to make marks on the diameter, equal distance from the center.

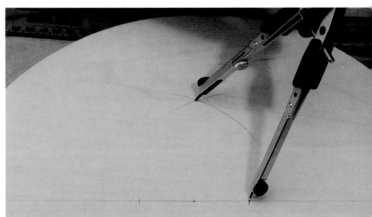

Expand the compass, put the point on each of the marks, and scribe arcs above and below the diameter.

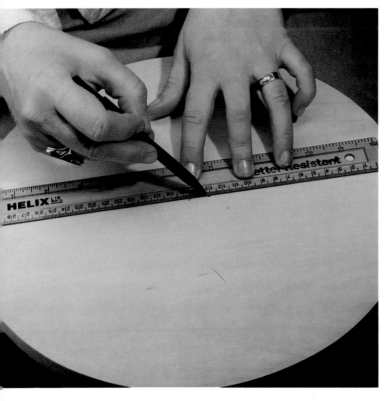

Draw a diameter through the center running with the grain.

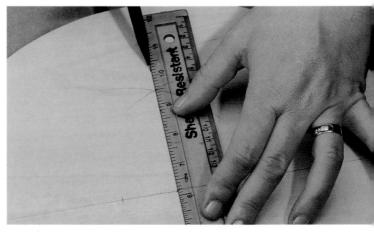

A line drawn through the intersections of the arcs will go though the center of the diameter and be perpendicular to it.

Erase all the marks except the perpendicular lines.

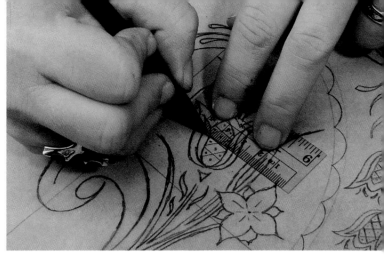

Use a ruler to draw any straight lines, making the pattern more perfect.

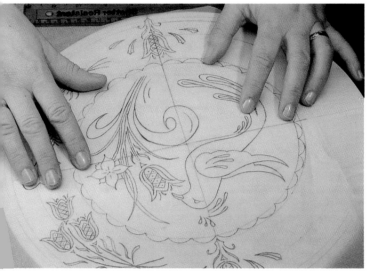

Enlarge the pattern from the book to fit your particular project, then transfer it onto tracing or parchment paper. Lay the pattern on the board, matching the cross lines, and tape one edge in place. I always like the grain running side to side. The plaque I am using measures 13" in diameter, with the Wilkom board measuring 16 3/4" across.

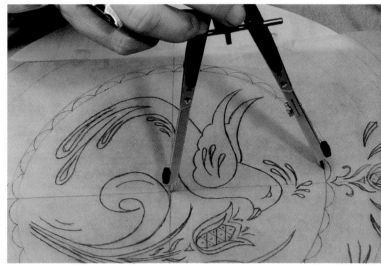

Use a compass to lay down the inside circle of the scalloped ring designs.

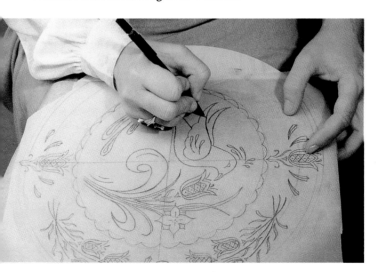

Put transfer paper under the pattern (graphite side down!) and trace the lines.

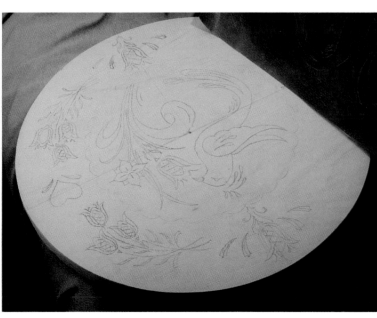

Check to be sure you have everything drawn...

then flip the pattern over and draw the other side.

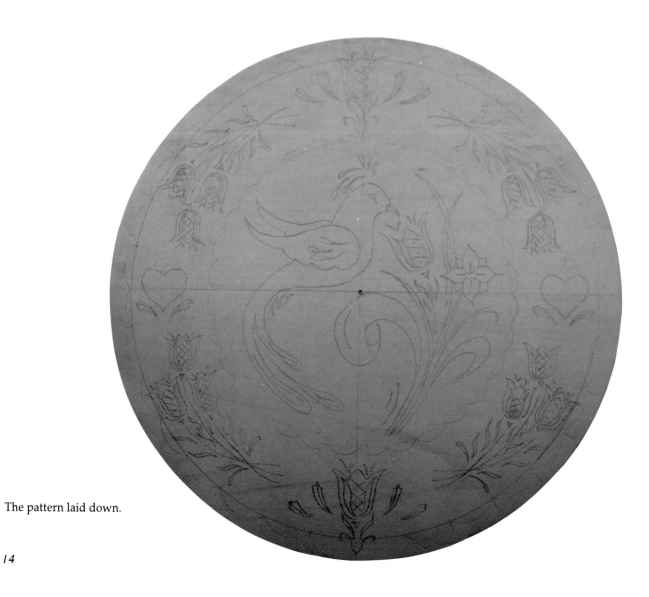

The pattern laid down.

CARVING THE WILKOM PLAQUE

Start with the tulip in the center of the plate. On the s-curves, start with your blade straight up...

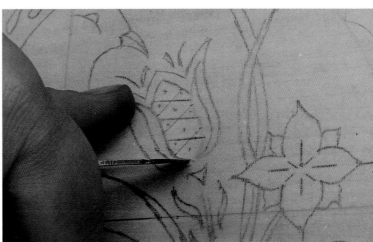

Start at the bottom of the cut and come up the other side in the same way: knife straight up...

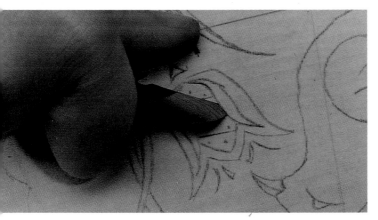

Lean it over at the middle of the cut...

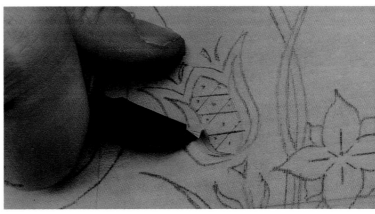

leaned over...

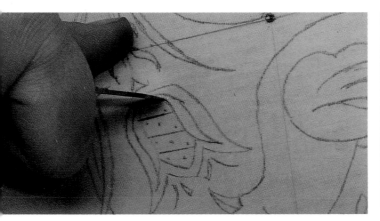

and end with it straight up again.

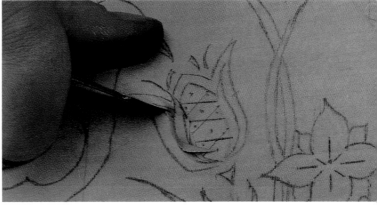

and straight up at the end.

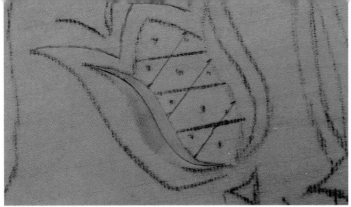

The result. Repeat on the other side.

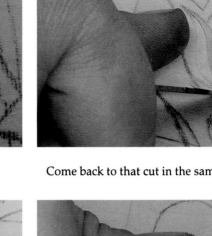

Come back to that cut in the same way, straight up...

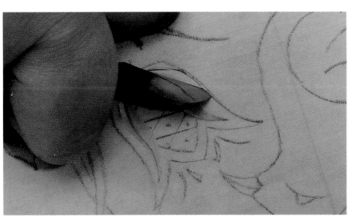

The outside curve of the tulip is the same process, but with a thinner line. Start with the blade up...

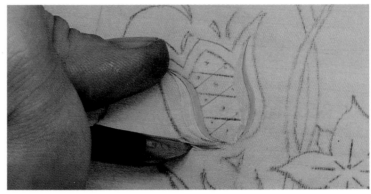

leaned over at the curve...

lean it over in the middle of the cut...

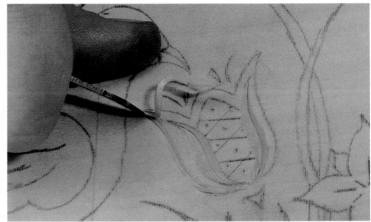

and straight up at the end.

Start the other side at the bottom inside and work up. This keeps you from undercutting the bottom of the tulip and popping the chip out.

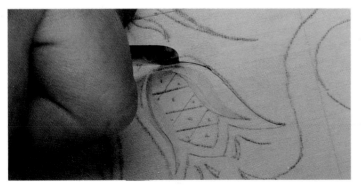

and end with it straight up again.

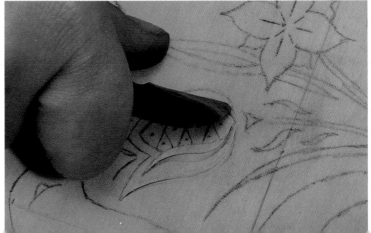

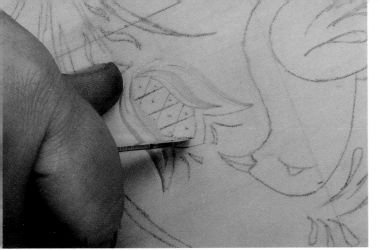

Cut the inside point, again, beginning and ending with the knife straight up.

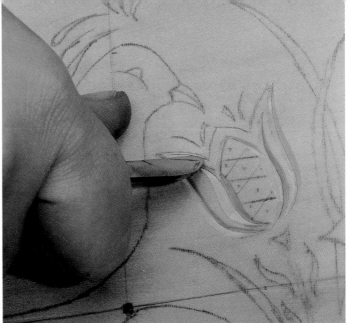

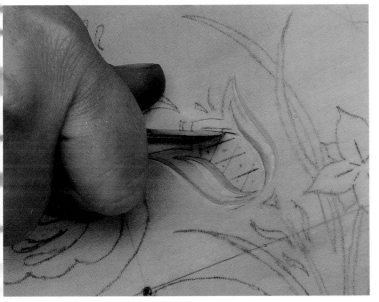

Again, when there are points, you want to cut back toward them on the first cut...

Come back on the other side.

Cut the other side starting at the point on the inside line. We have two points to be concerned with here, one at the beginning of the cut and one at the end. You want to cut toward the more delicate of these points, in this case the one at the bottom. By cutting toward from the delicate point, you get the nice clean line you are after and avoid breakage.

and away from them on the second. When there are two points you'll need to decide which is in more danger of breakage.

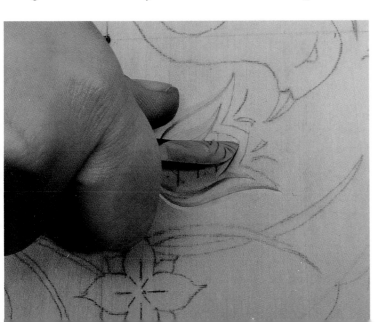

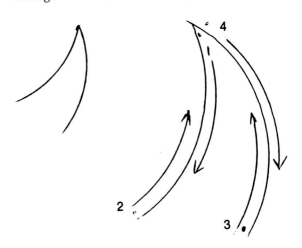

On the center point I work from the top down on the first cut and come back to it on the second. Some of the directions of cutting will have to learned by trial and error. It depends on many factors, including whether the curve is concave or convex, the direction of the wood grain, and the other cuts around it.

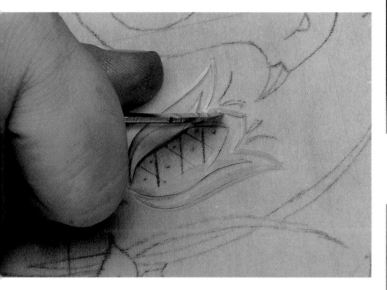

Go back and clean up the cuts, straightening where necessary.

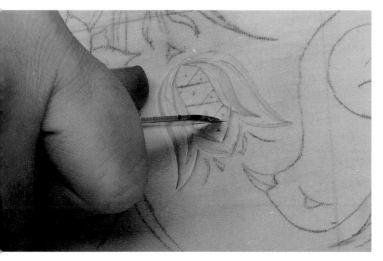

The lines in the flowers are very thin. The first cut should have the knife straight up and down.

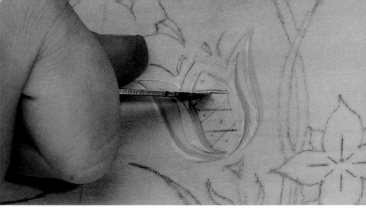

On the back cut, the knife should lay over only slightly, enough to take out a thin wedge.

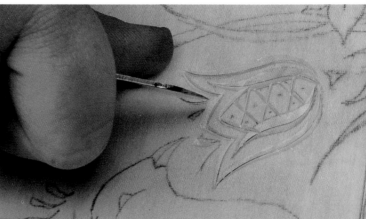

On the thin piece above the flower, I cut the concave side of the cut before the convex.

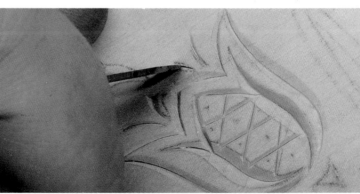

The thicker accents at the top of the tulip are done with three cuts...up one side...

across the top...

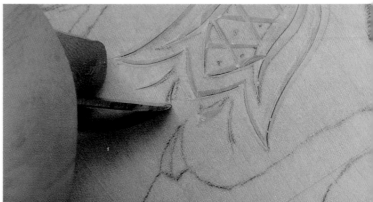

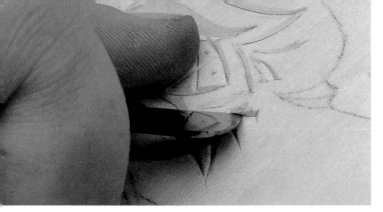

and down the other side.

On the large leaf start at the point and cut the convex side with the knife only slightly laid over. On convex curves, the sharper the curve, the straighter the knife.

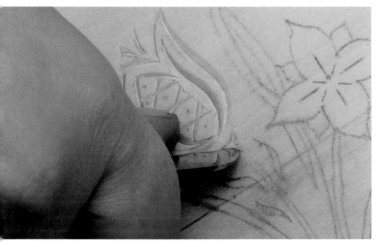

For the chip at the bottom, cut one side using hand position 1...

Continue all around one side of the leaf.

the other side using hand position 2...

and the third side using hand position 1.

Cut back to the line, starting with the blade almost straight up until about this point. Now lay it over for the curve.

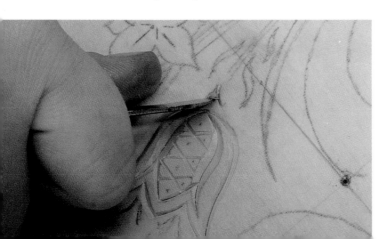

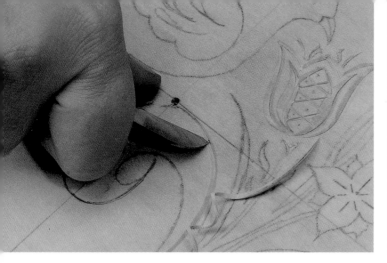

Continue to cut, letting the grain take the knife to the outer line. Stop there, move back and pick up the curve again. Repeat this process through the curve.

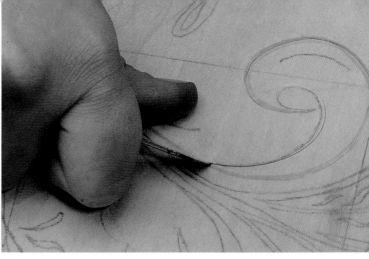

Repeat the process on the other edge of the leaf.

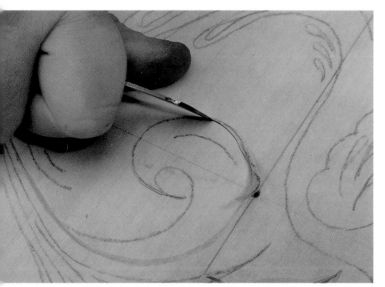

This is the next segment of the curve.

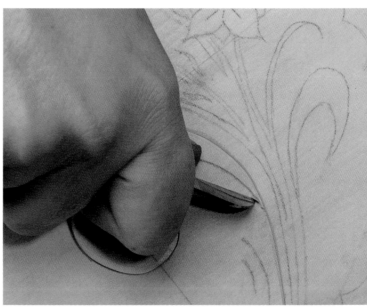

Coming back you want to cut easy and light at the beginning of the cut, with your knife straight up. If you don't you may lose the point inside the leaf. Keep pivoting the piece around as you cut this curve.

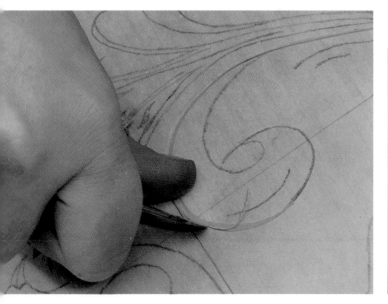

I have to go back and clean up the cut.

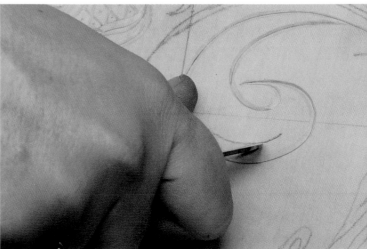

Cut the accent line in the surface of the leaf.

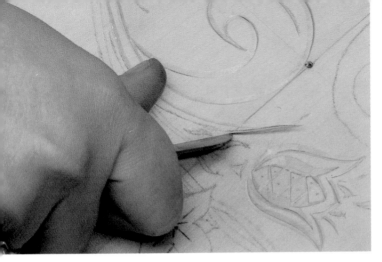

Cut the other leaves in the same way.

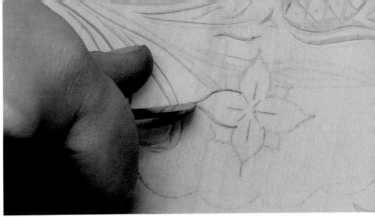

Come back down the other side up to the point.

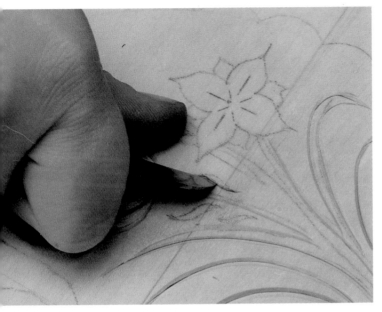

The smaller leaves are done using the same s-curve technique we used on the tulip blossom.

When the blossom is done you can finish carving the top of the leaves.

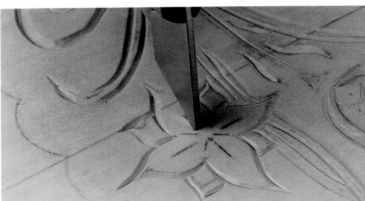

The lines of the blossom are made with a stab knife. Stab it in...

Incise the lines of the other blossom.

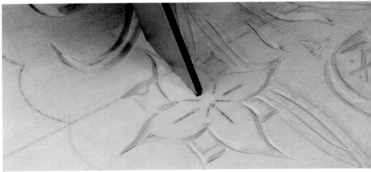

and rock it back.

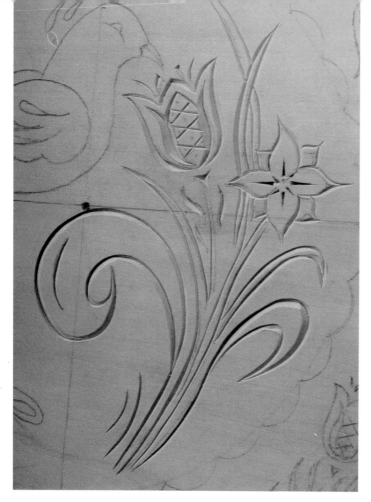

The flower done. Be sure not to carve through the top of the leaves where one is to go behind the other.

The bird is the central design feature of the plate. We start with its wing, beginning at the tip.

Work your way around the wing, making sure that the tips at each point match.

Remember to start the cuts from the tip of the wing to protect it from breakage.

Continue working around the body, beginning here where the back wing meets it.

Cut the top....

and the bottom of the beak with a very light cut. Use almost no pressure in the hand.

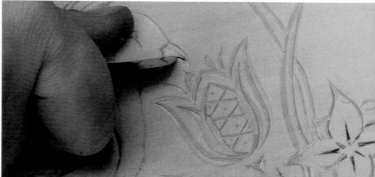

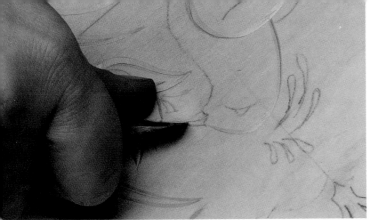

The center line of the beak does not come to the point, but we want it to look as though it does.

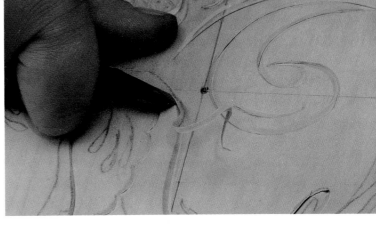

Cut back with the knife laid over.

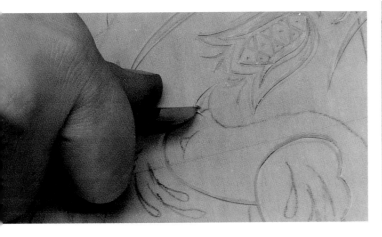

Cut the lines at the back of the beak.

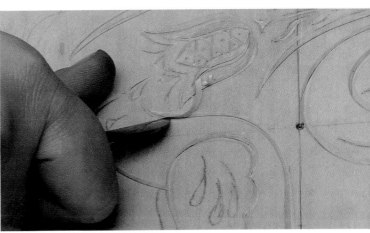

I go back and enlarge these lines, adding dimensionality to the bird.

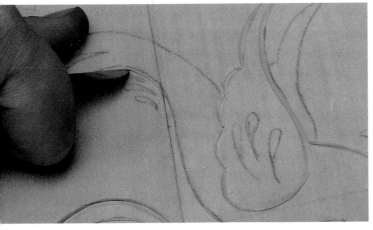

Start at the bottom of the beak and cut the curve of the body.

At the tip of the feather the curve is very tight, so keep your knife straight up and your hand loose. Too much pressure at these points and the knife will chatter.

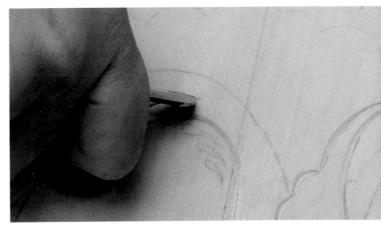

Start the cut of the back from the point between the tail feathers.

In the detached feather I start at the point and come around the end to about this point. This gives me the ability to blend it with the point.

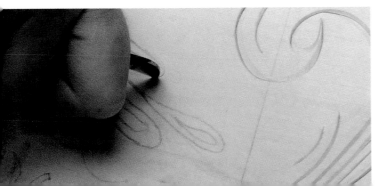

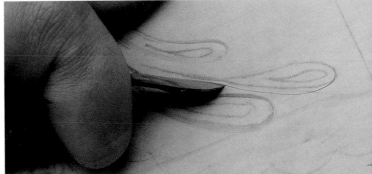

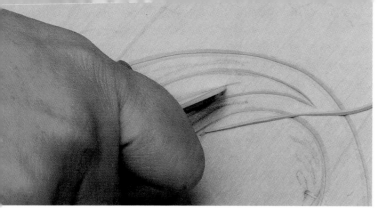

Cut back to the first cut around the feather...

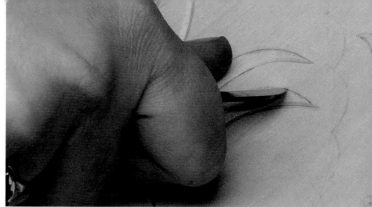

Start the under edge at the point.

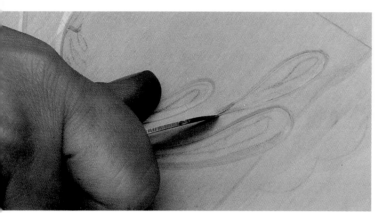

then blend the return with the line of the point.

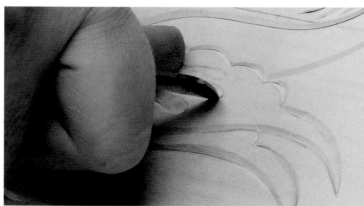

The teardrop designs will take some practice. The start at the tip of the wider portion, with the knife going straight in.

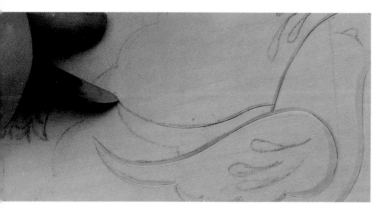

Cut the top edge of the back feather from the shoulder to the point.

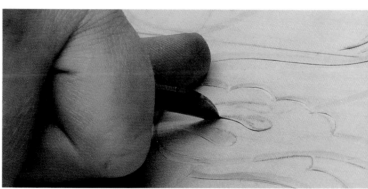

Follow the curve back to the point.

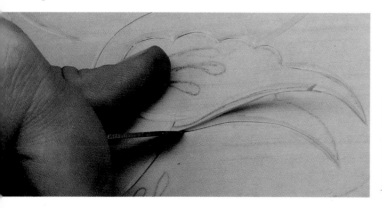

Cut back to the line.

Come from the point back to the tip.

24

Cut the bottom line of the eye, and come back over the oval with a light touch.

The tulips around the edge are the same as the one in the center. When doing the stems, carve the center one first. Keep the knife blade straight up, or when you come between the tulips you can easily to chip off an edge.

The straight up blade also helps when you cross the other stems at the bottom.

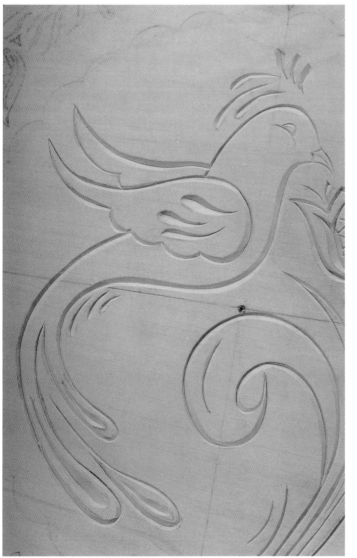

The bird complete.

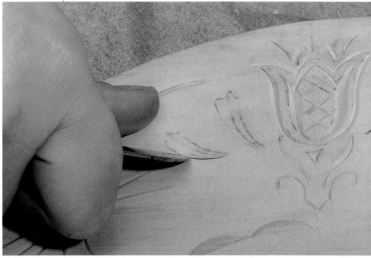

All of these divided triangular figures start on the right side. Work from the point, gradually laying the knife over.

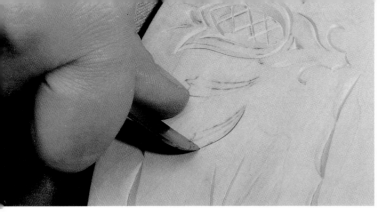

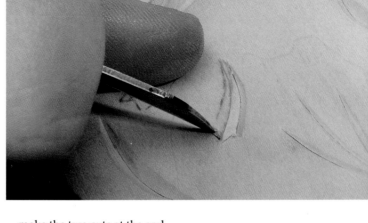

The end cut is actually two, the first angled back...

make the two cuts at the end...

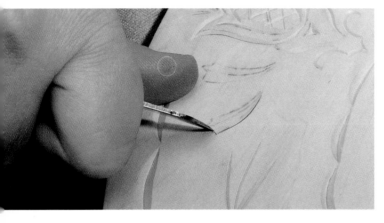

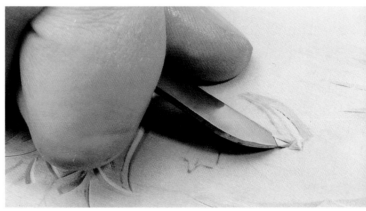

and the second coming out to the end of the center line.

and cut back to the point. Begin with the knife cutting in at a deep angle...

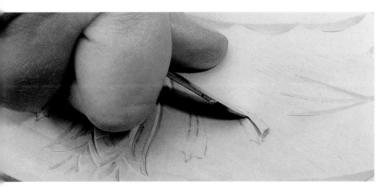

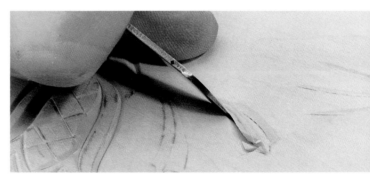

Cut back to the point along the center line.

and bring it straight up and down as you reach the point.

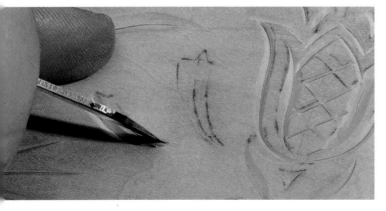

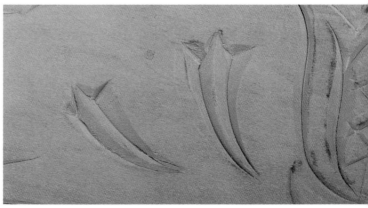

On the other side of the center line come back from the point...

It should look like this.

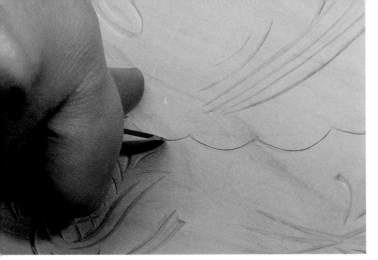

The scallops are simple, but when going with the grain you may need to lightly cut the fibers before going deeper. This will give you more control of the knife and keep the grain from carrying it away.

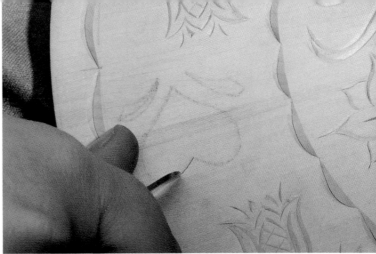

Start at the point in the top of the heart and work your way around to the other point.

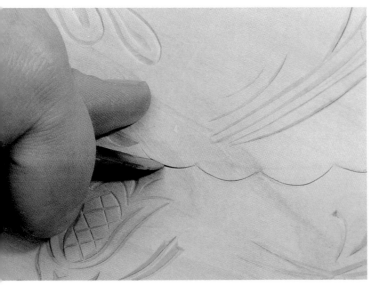

Cut the oval shape first.

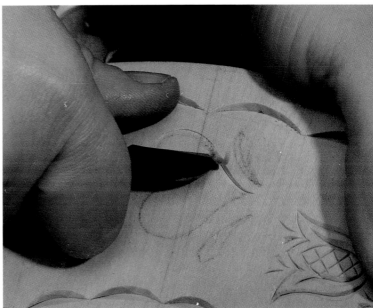

Come back on the other side of the line. Because it is a tight circle you'll need to pivot the piece to make the cut clean.

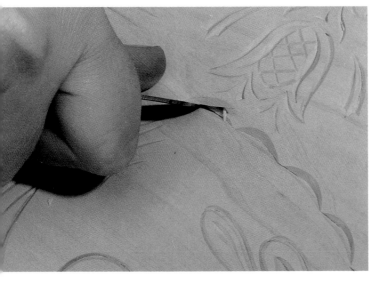

Then come back and cut the inside circle.

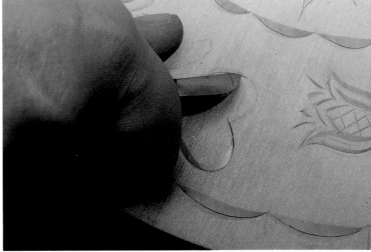

Because the points of the heart need to be even, I start here at the side...

27

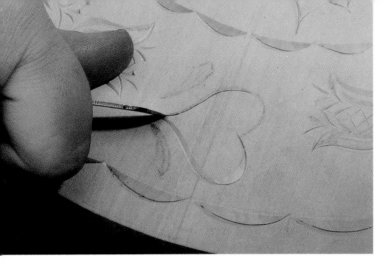

and make my inside cut down to the point.

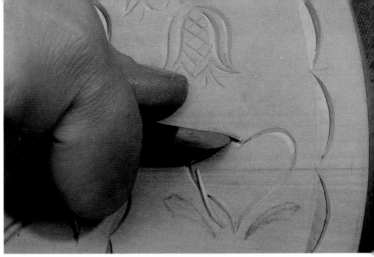

Now that I can see what I've done, I can make a clean cut from the top point back to where I started. This is another cut where you let the grain carry the knife on the curve, and stop and restart it to get the roundness you desire. For more information see my book *Basic Chip Carving*, Exercise Seven.

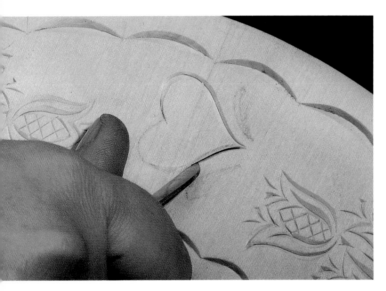

I then come up the outside of the heart...

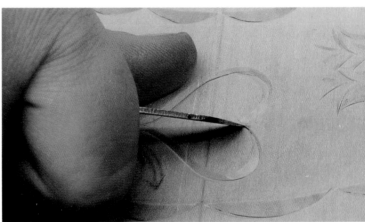

Go back and clean up the inside point at the top. I use hand position 1 for the first cut...

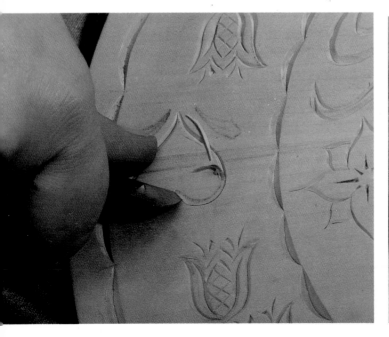

all the way back to the other point.

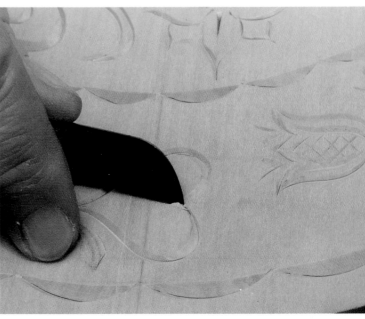

and come back to it with the knife held in position 2.

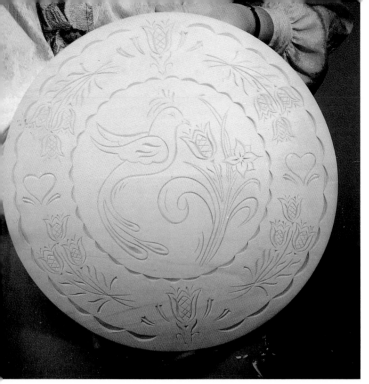

The plate carved.

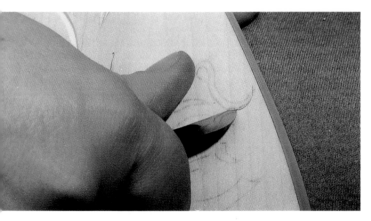

The hearts and decorative work on the sign portion are the same as on the plate. The lettering in the upper part of the sign is next. Whenever you do lettering you need to consider the letter as being made up of several parts or elements. Start on the convex part of the curve...

and go from the point to about here.

Move to the other point and carve back. You will begin removing the body of the s-curve.

Go to where you left off the first cut and come back to the point.

The result.

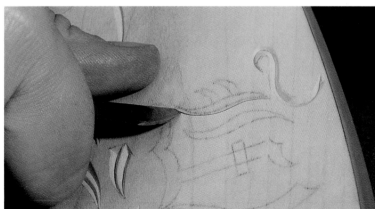

The next two elements of the "W" are s-curves as we have done before.

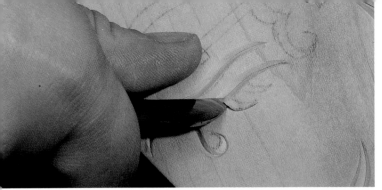

The decorative flourishes on one of the s-curves are cut from the point right into the s-curve.

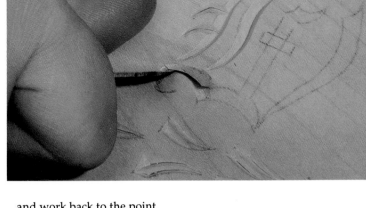

and work back to the point.

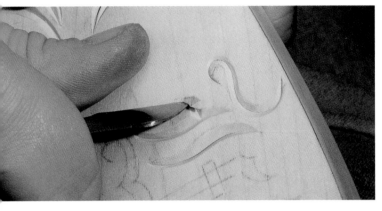

Cut back to the point and the wedge should pop out.

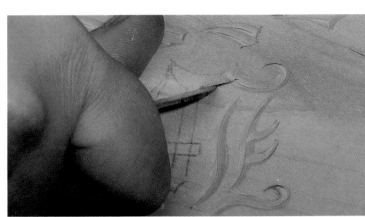

The next segment is wide so really dig the knife in at the beginning...

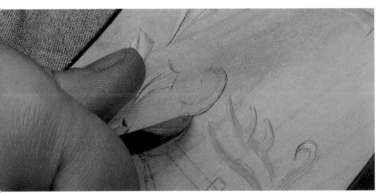

The bottom portion of the "W" is handled in segments. Start at the point and come to the first joint, cutting all the way to the bottom line.

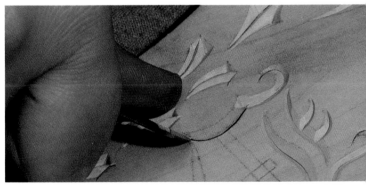

and lighten up and come out as you reach the end.

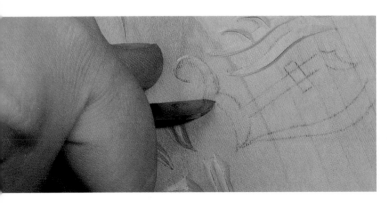

Cut an end here...

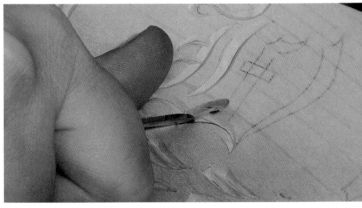

Cut the other plane.

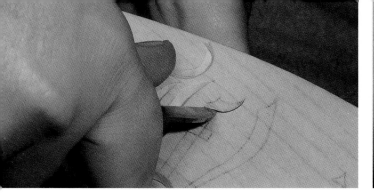

The top of the middle element of the "W" is handled as a triangle. Start at the point and come across the upright element.

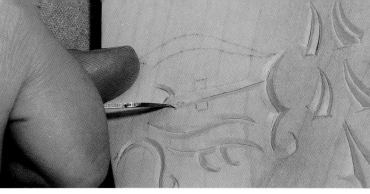

You may need to go back and clean up the intersection of the top and the straight elements.

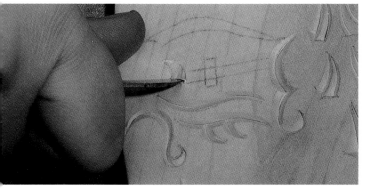

Cut the short end of the triangle...

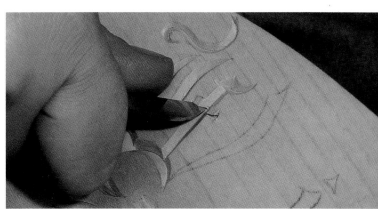

Cut the cross piece.

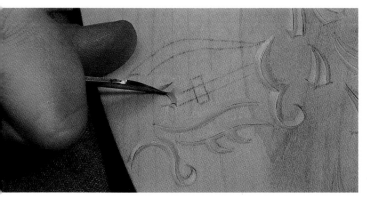

and come back to the point along the other side.

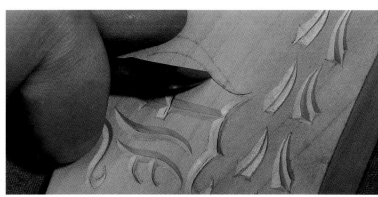

The third element of the "W" is a long curved triangle. With the knife laid over start at the point and cut up to the top.

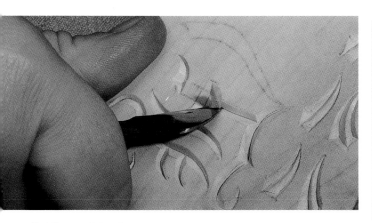

Cut the straight element with the knife laid over at the same angle on each side.

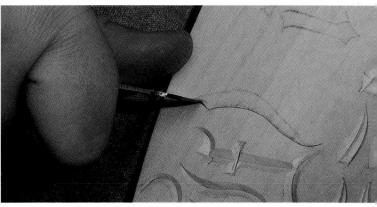

Cut the short side...

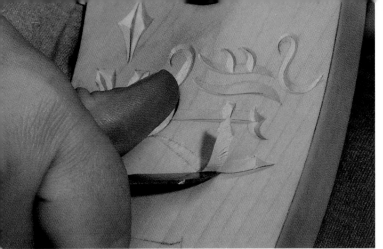

and come down the other side, back to the point.

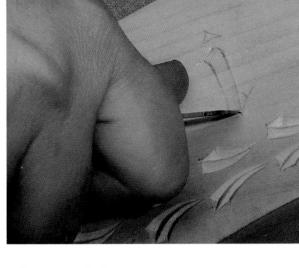

Come across the bottom...

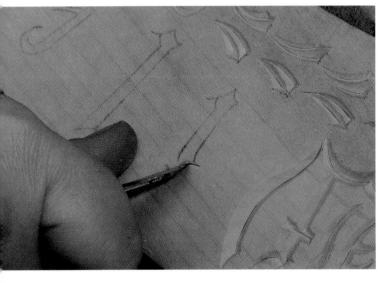

The "i" and "l" begin by cutting across the top...

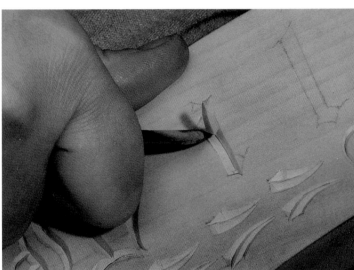

and straight up the other side.

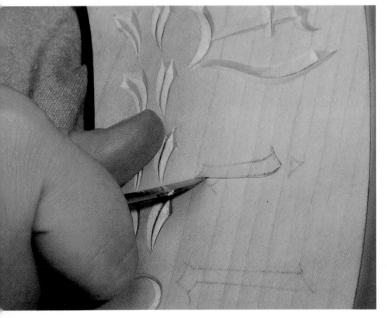

Then straight down the side. Don't worry about the serif for now.

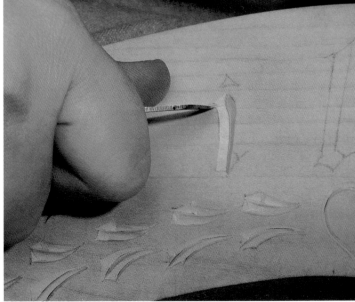

The upper edge of the serif at the top was cut on the first cut, so we need to cut back to it on its underside.

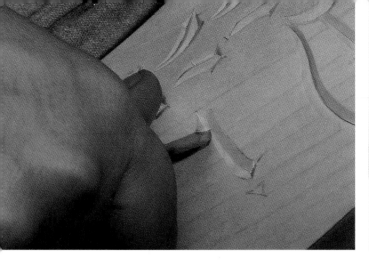

At the bottom serif, first cut the top edge.

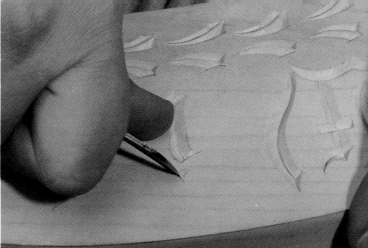

Three curved cuts make the dot of the "i". One...

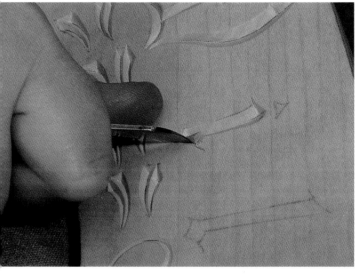

then cut the bottom.

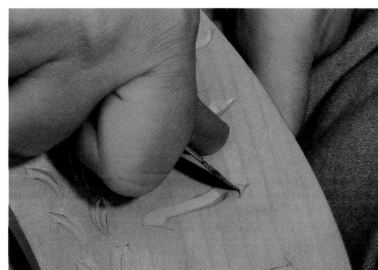

two...

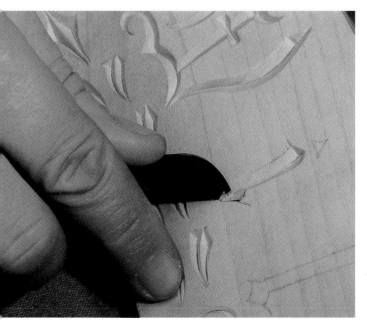

With the knife held in position 2, clean out the corner of the serif.

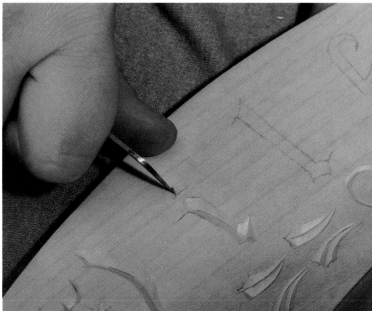

three.

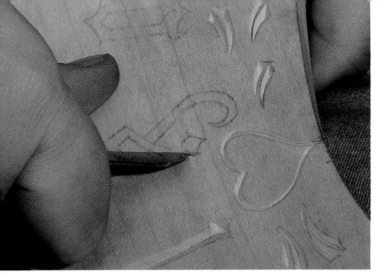

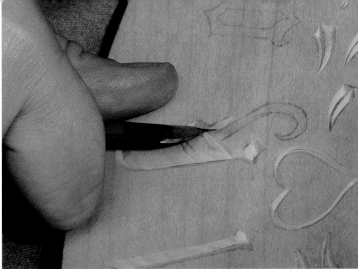

The "l" is done like the "i". At the "k", start with the serif and come up the long side curving around at the top.

and come back to it around the inside.

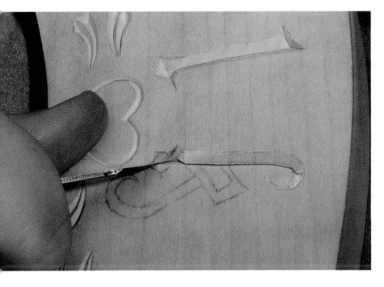

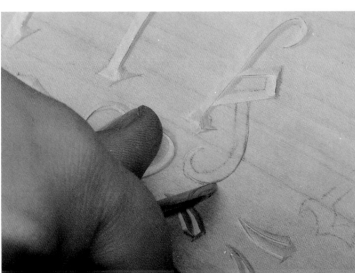

Come back down the other side, going straight to the bottom. clip it off with cut at the bottom, and cut the serif just as you did the "l" and the "i".

The bottom of the "k" is done the same way as the top. Cut down one side and come back to it from the other.

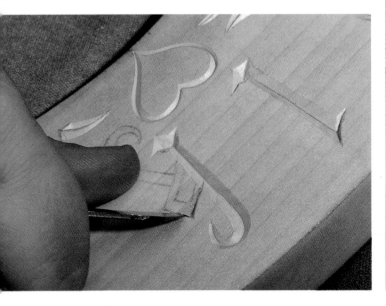

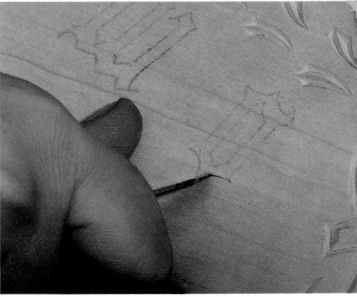

Cut around the outside of the loop of the "k"...

Start the "o" by going from point to point at the top.

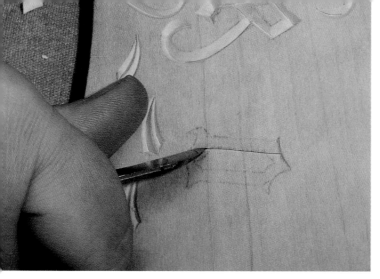

From that cut, come down the inside of the opening.

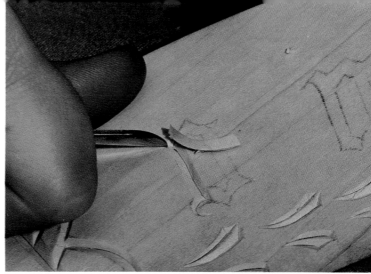

Come up the outside of the first element of the "o".

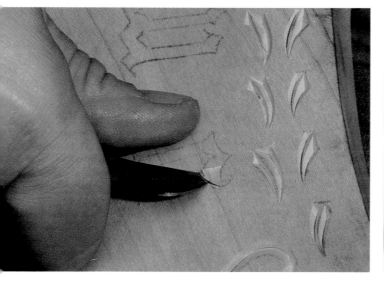

Start at the point of the bottom serif and come around to the inside line.

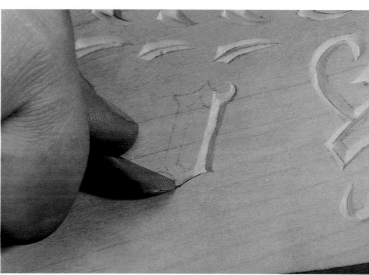

At the top of the "o" begin at the point with the knife straight up and cut to the end of the serif.

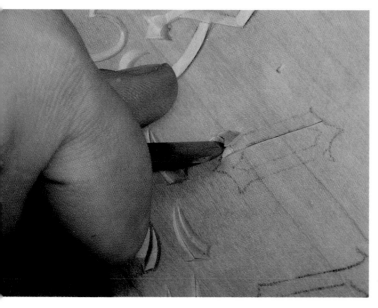

Cut the lower line of the serif. The chip should pop out.

Cut out the left side of the top.

Then work from the point of the serif and cut out the right piece of the top.

Cut down the outside of the right element of the "o".

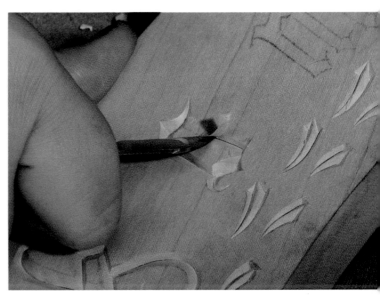

Cut the inside line of the bottom element, carrying the cut to the opposite side.

Cut back up the other side.

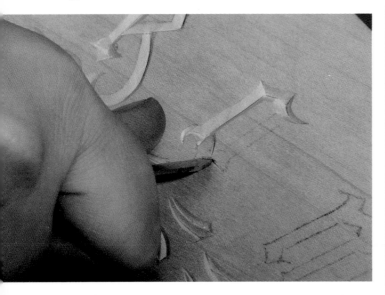

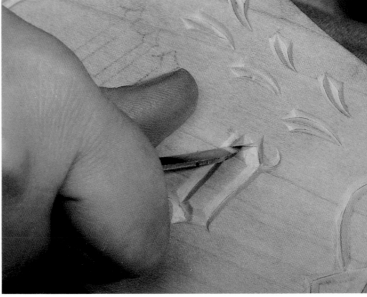

From that point cut along the bottom edge to the point, and from the point up the serif, completing the lower left hand side of the "o".

Make the final cuts at the bottom of the element...

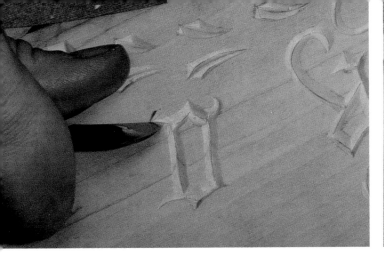

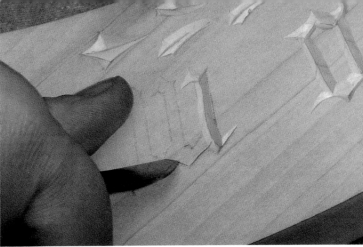

and finish the "o" by cutting out the small flourish at the lower right corner.

down to here...

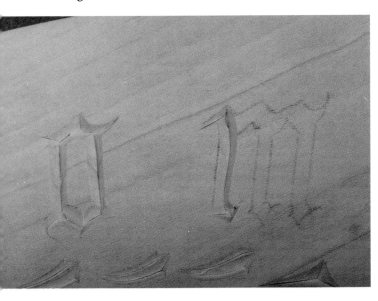

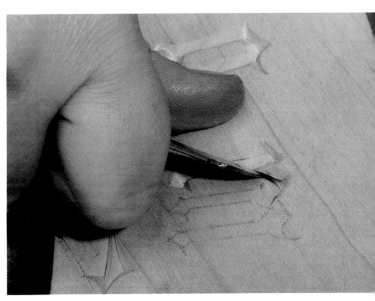

Do the first element of the "m" much as you did the first part of the "o".

and back across the bottom edge to carve the first section of the top.

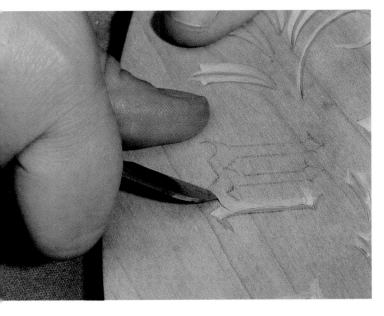

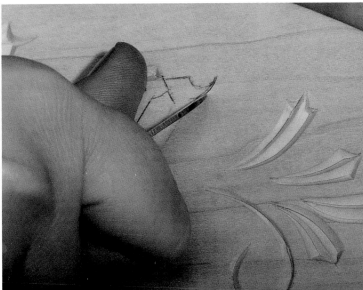

Come across the top...

Cut a curve from the right end of the top...

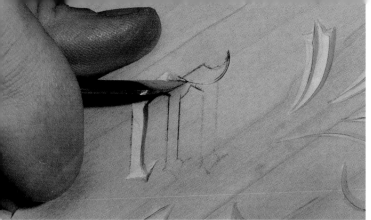

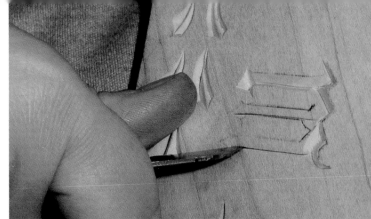

back to here.

The two other legs of the "m" are handled just like the "i" and the "l", down one side and up the other.

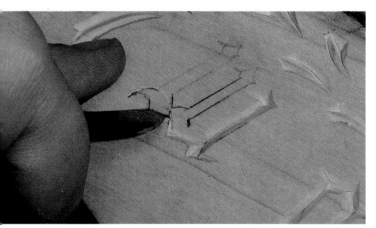

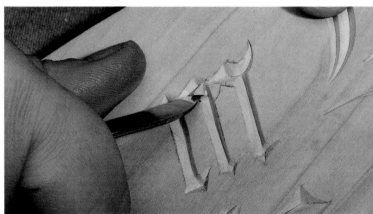

Cut back to the corner in segments. The first...

From the top of the center leg, cut the angles of the cross members, first this way...

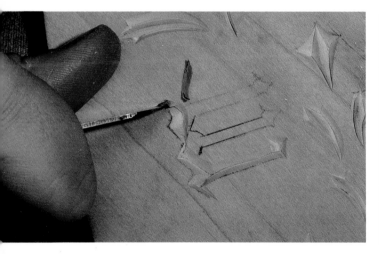

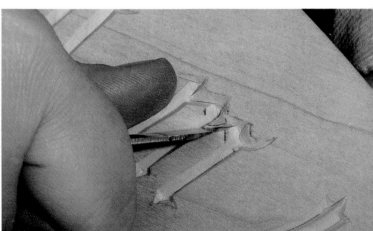

and the second, which is curved.

then this.

The result.

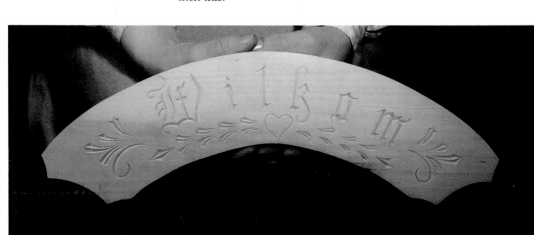

LAYING OUT THE BIBLE BOX

I begin the bible box with the lid. Layout starts with a line 1/2" from the edges. Measure and draw a line all around.

Find and mark the center of each side.

Measure in from that to make 4 marks spaced at 1/8", 1/4", 1/4", and 1/8" apart.

Draw the midlines.

Use those marks to draw lines all the way around the lid.

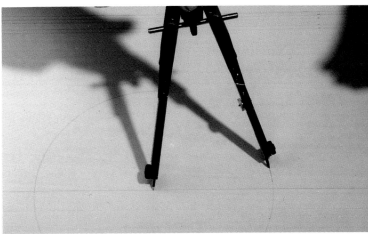

Use the pattern to set the compass to the outer circle of the center design and scribe it on the lid.

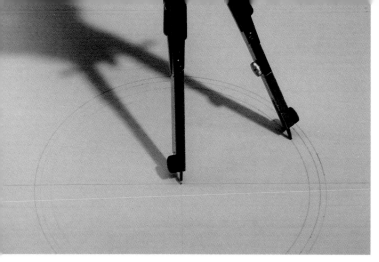

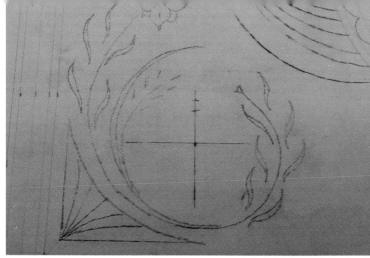

Repeat with the two other circles of the center design for this result.

For the rosette just mark the compass marks and the mid-lines.

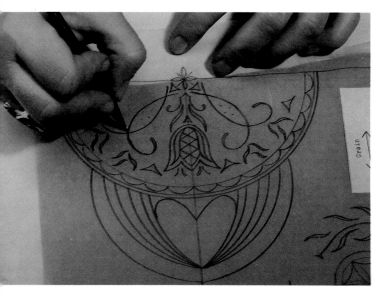

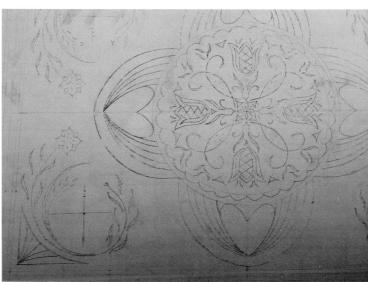

Align the center pattern with the midlines and trace.

The traced pattern complete.

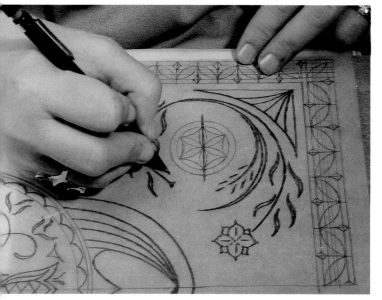

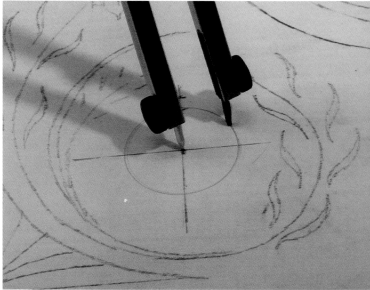

Align the corner pattern with the inside line of the border and trace.

Set your compass to the inside mark of the rosettes and draw a circle.

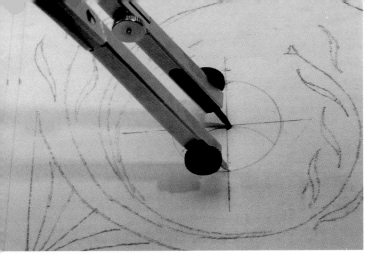

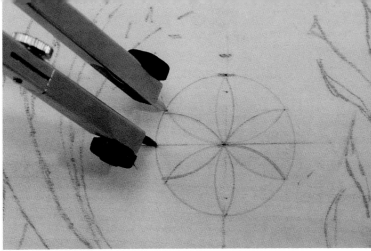

With the compass at the same setting put the point at the bottom where the midline crosses the circle, and draw an arc.

Set your compass from the end of a petal of the rosette to the nearest midline.

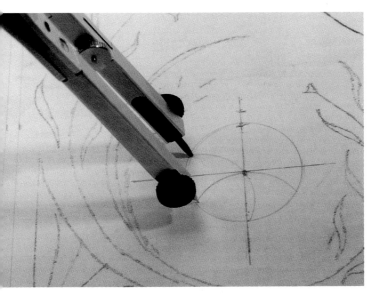

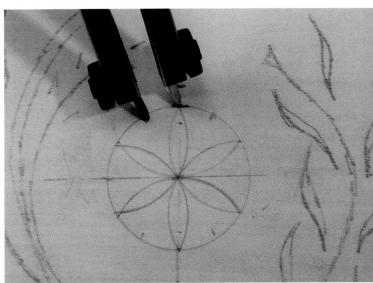

Where that arc crosses the circle, place the point of the compass and draw another arc. Continue walking around the circle...

Use the setting to mark midway between the rosette petals.

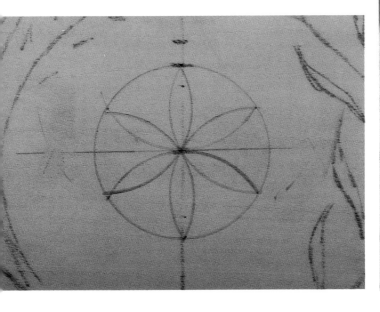

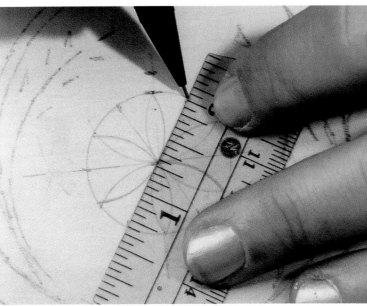

until the rosette is complete.

Connect these marks through the center.

Laying out The Border

BIBLE BOX BORDER
Shows drawing procedure.

Drawing A

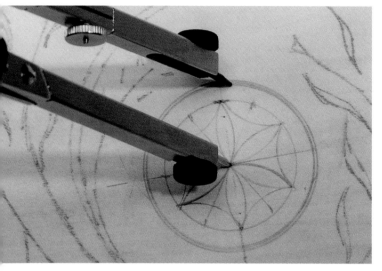

Use a coin or other round object to mark arcs from point to point on the inside of the circle.

Set your compass to the outside mark and strike a circle. Then close the compass and draw one of slightly less diameter. This gives a fatter line.

Use your compass to divide the length of each side of the border. This is done by halving it again and again until there are 16 segments from the center out to each side on the long edge and 8 segments from the center on the short edge. Remember the segments should be of equal length.

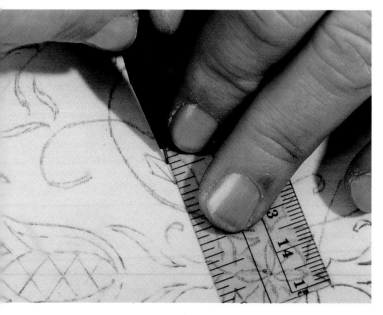

Connect the dots in the center pattern to form diamonds.

Draw perpendicular lines at the marks across the inner lines of the border.

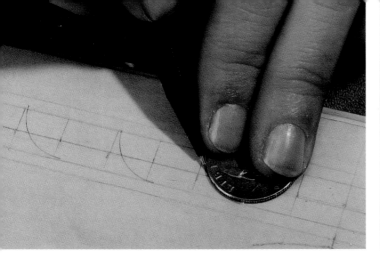

Use the quarter again to draw a quarter circle in every other border segment, going from the second to fourth lines.

The corner oval is done in the same way.

Remember to divide <u>your</u> border equally.

add these lines

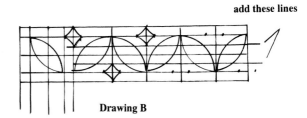

Drawing B

Come back the other way to draw the other quarter circle. This will look something like a half circle, but in fact it is two quarter circles that meet at a point.

Come back with the quarter and complete the pointed ovals of the pattern.

To draw the diamonds you now measure out 1/8" on both sides of the center line and strike a line the length of the border. We waited until now because earlier it would have confused our work on the oval.

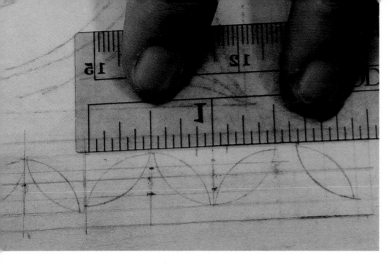

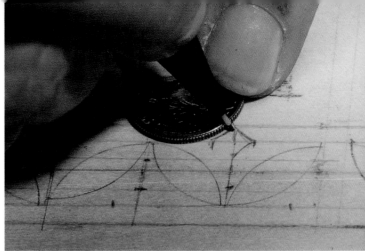

On the second line in, measure 1/8" on both sides of the segment lines that divide the ovals.

Use a dime to connect the points and create a curved diamond.

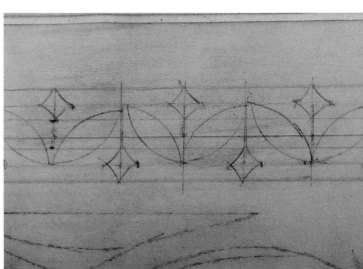

After marking one, you can use the compass to carry the marks to the other points. This process is tedious and some people may choose to eyeball this measurement. I prefer to mark each to insure precision.

The border pattern drawn.

A rosette grid pattern is used on the end panels of the bible box. Begin to lay it out by measuring in from the ends 1" and marking. From the top and bottom measure in 1/2" inch and then 1/8" from that. Find the center of each side and draw midlines, across and up and down.

Use the compass to quarter the end lines, measuring from the inner lines of the long edges.

Make a mark 3/16" inside the circumference of the circle.

Use the same compass setting to measure out from the center on the top and bottom lines. Don't worry if it does not match up with the end lines. Those were primarily for finding center. Connect the lines to form a grid of squares.

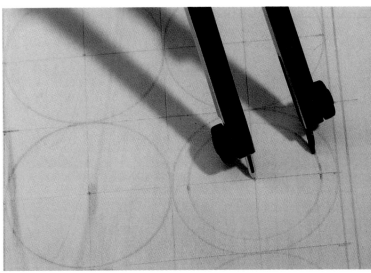

Set your compass to this mark and draw an inner circle in each of the larger circles.

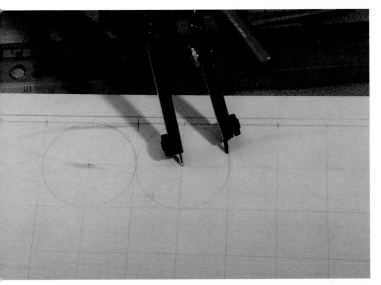

Working out from the center, draw circles with the radius of one square. These should touch but not overlap.

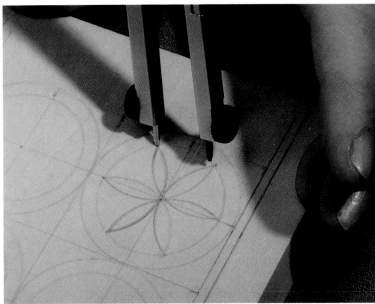

With the compass still at this setting, create a rosette as you did on the lid, starting at a vertical line.

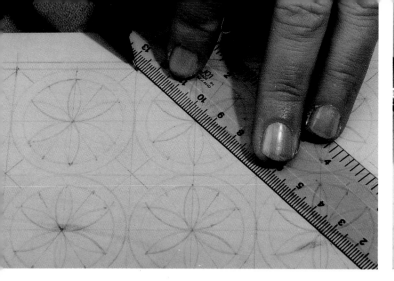 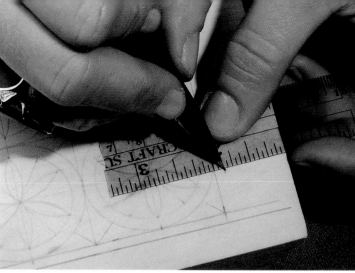

To set the inside corners lay a straight-edge from corner to corner across two squares and draw between the rosettes. Go in both directions.

Come 1/8" from the ends of the rosette pattern and draw the end lines.

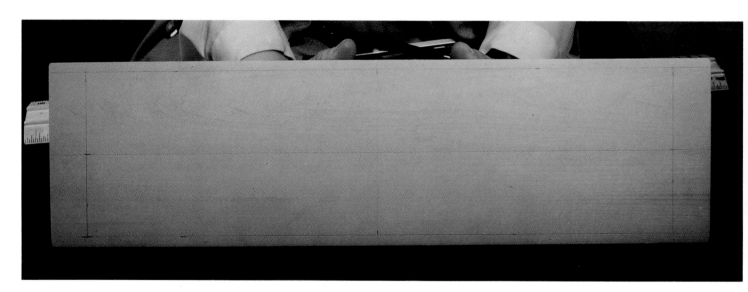

To lay the front pattern of the bible box, simply establish center lines in both directions. Begin by measuring in 1" on the ends and 1/4" top and bottom.

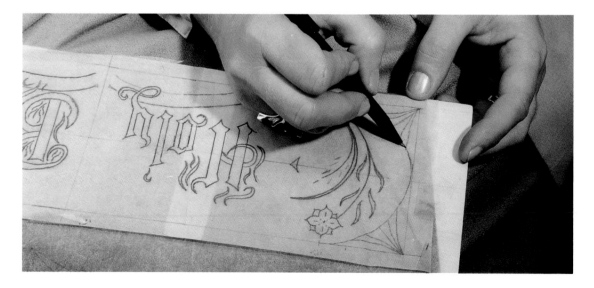

Align the front pattern with the center lines and trace it.

CARVING THE BIBLE BOX

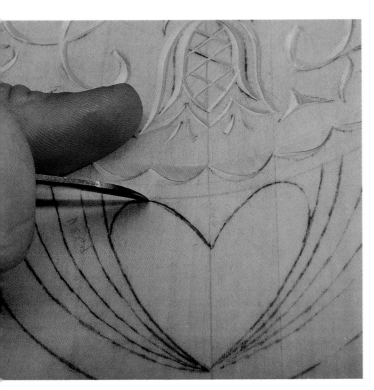

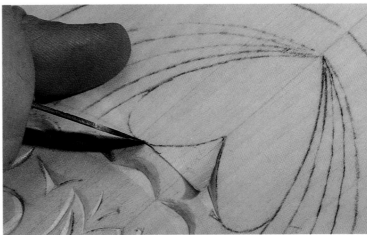

and bringing it up straight at the end again.

Much of the carving on the bible box uses the same techniques we used in the Wilkom plaque earlier in the book. Begin carving from the center out. Complete the center rosette. There are some new things however. The space at the top of the hearts is basically a three-sided triangle. Begin by cutting up the edge of the upper lobe of the heart.

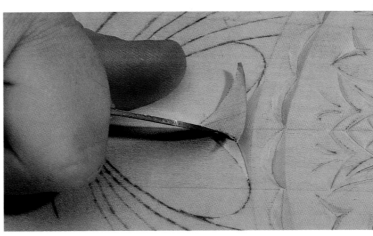

Come back down the other lobe to the point.

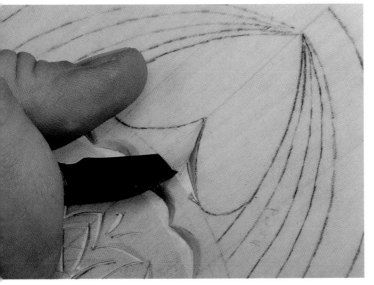

Follow the line of the ring across, starting with the knife straight up, laying it way over in the middle...

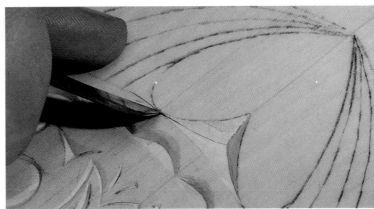

At the top of the heart make a shallow scribe mark...

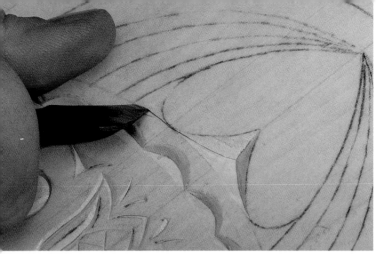

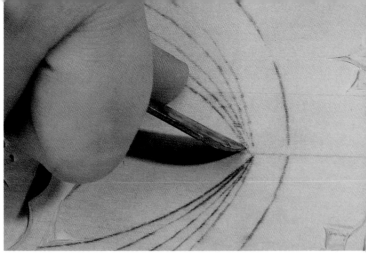

until you get to the next space, when you go deeper.

Start the pattern of adjacent elongated triangles at the tip of the heart. Cut up the edge of the heart...

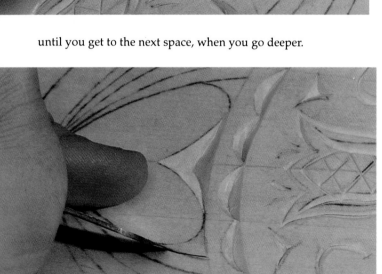

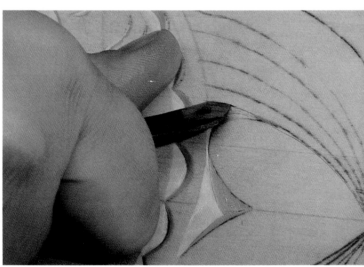

Come down the pattern...

then continue the line to the ring at the end of the elongated triangle.

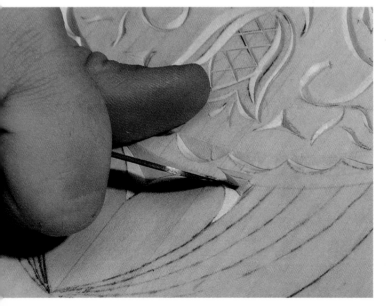

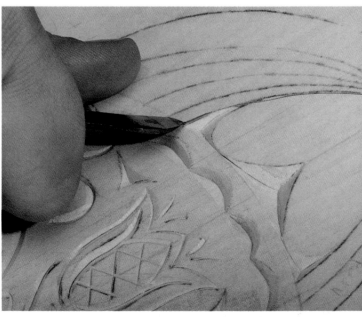

and back up the side of the heart, cutting and rolling at the same time to follow the curve. When you get to the top, go to a shallow cut again to complete the scribing.

Cut across the top...

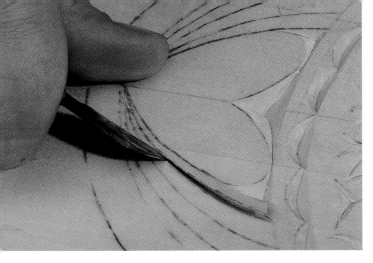

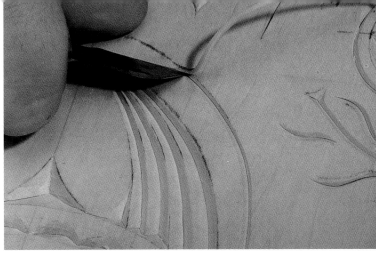

and back the other side. On some of these cuts, like here, you will be going with the grain, and the grain will have the tendency to carry the knife off the line. Cut carefully, walking the blade if necessary. If you have real trouble, try a light cut first to break the fibers of the grain.

Incise the curved ring around the center pattern.

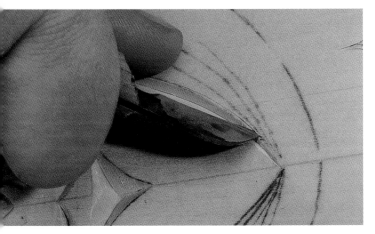

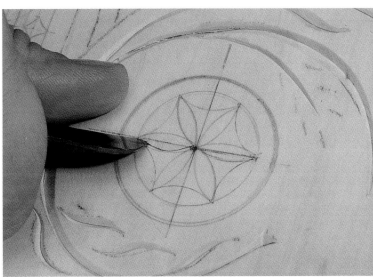

With these triangles so close, every one does not need to come all the way to the point. This second one will start a bit back from the point, and the next one will make it look right.

The petals of the rosette are simply pointed ovals. The cut starts shallow and straight, lays over and goes deep in the middle, and ends shallow and straight. Do one side...

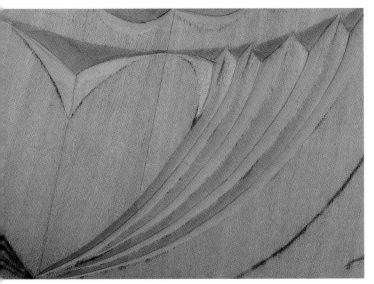

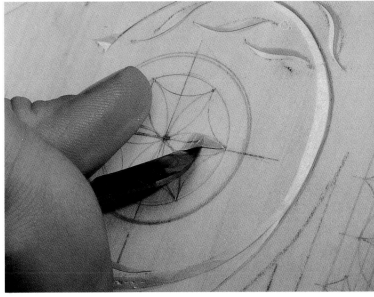

The result. The other side of the pattern is done the same, except that it starts at the triangle furthest away from the heart.

and the other.

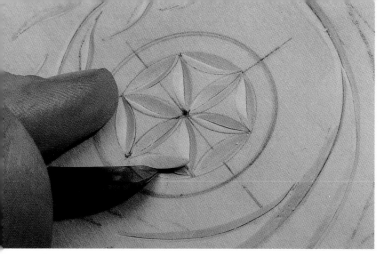

The ovals around the rosette are done in the same way.

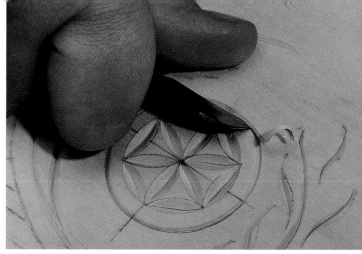

Starting at the stop cut again, make the inside cut with the knife laid over. This is a pivot cut, stopping and starting as the grain requires.

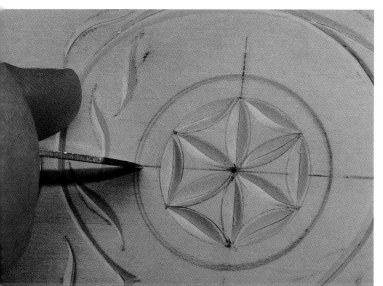

Begin the circle around the rosette with a stop cut, going with the grain.

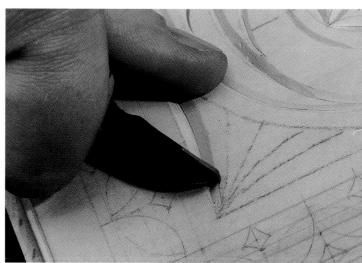

The patterns in the corners are done basically the same as the patterns beside the heart...

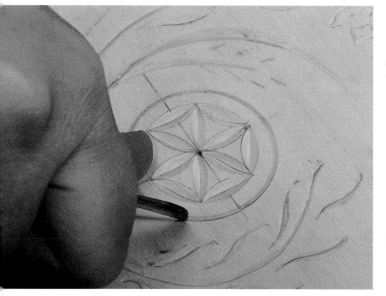

Cut the outside of the circle with the knife almost straight. Begin at the stop cut.

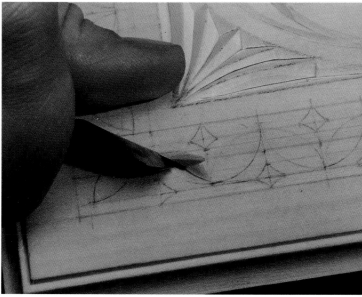

and the ovals of the border are like the ovals of the rosettes.

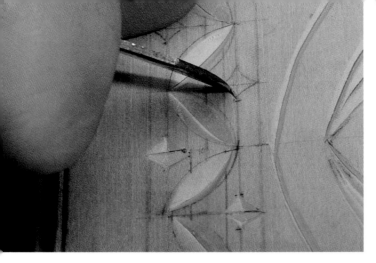

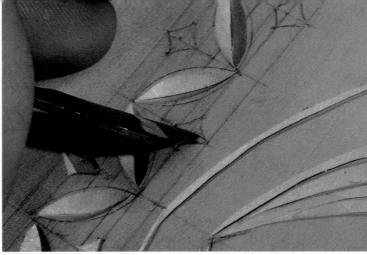

The diamonds in the border and in the center pattern are two adjacent triangles. The first triangle begins in position 1...

The second starts along the adjacent side with position 1...

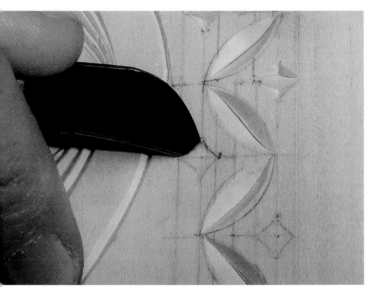

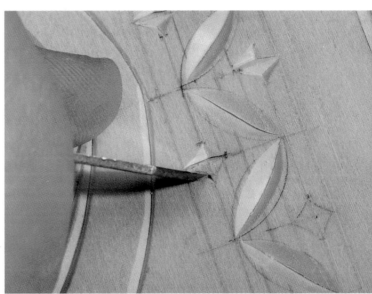

with the second cut in position two...

position 1 for the second cut...

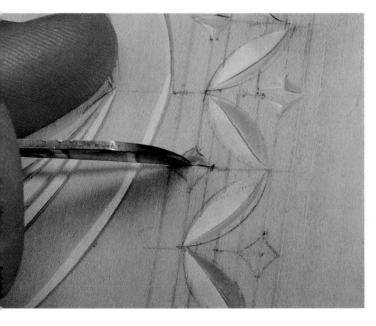

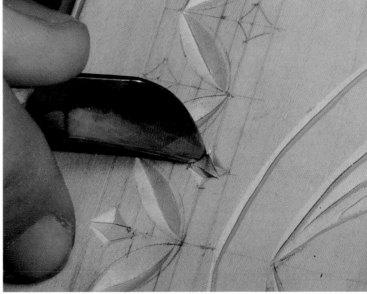

and the third, along the center line, in position one.

and position 2 for the last.

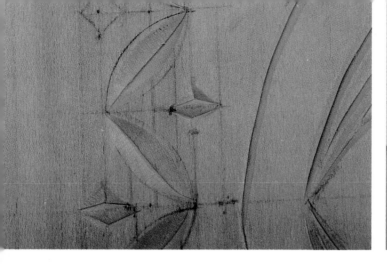

The result.

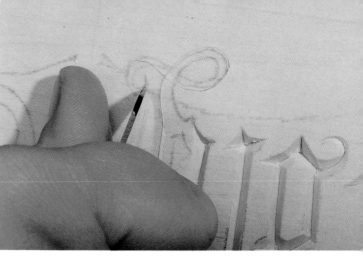

Start at the point of the flourish, cutting loosely...

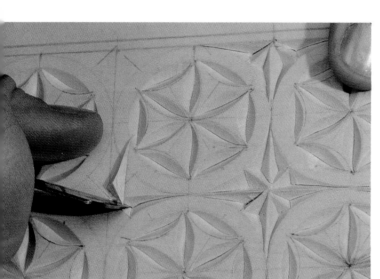

The side panel rosettes are the same as the top. The diamonds and the half diamonds between them consist of series of adjacent triangles around a center. When the rosettes and diamonds are carved, incise a line around the border.

to here.

The letters on the front use the techniques on the Wilkom plaque, though there are a few new steps. The right side of the "y" begins with one flowing cut from the top of the right element to about here. On the tight curve keep a loose hand.

Cut back along the other side to finish the cuts.

Cut across the ends of the vertical element in the "B".

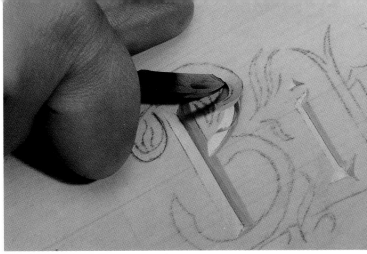

Come back around the inside to clean it up.

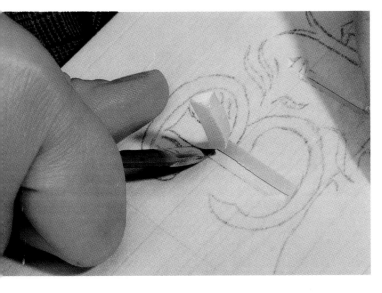

Then cut the long sides.

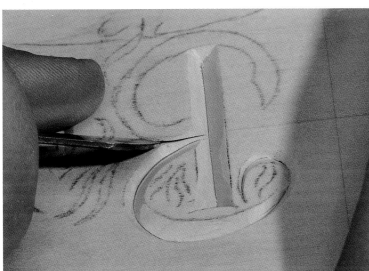

Start the outside cut of the bottom of the "B" inside the bevel of the upper edge. Leave a slight ridge.

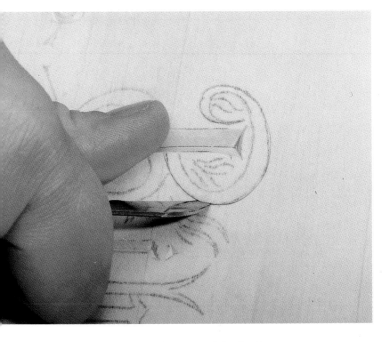

Cut the outside curve of the top of the "B."

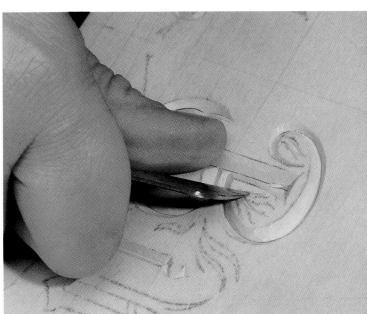

Carve the details.

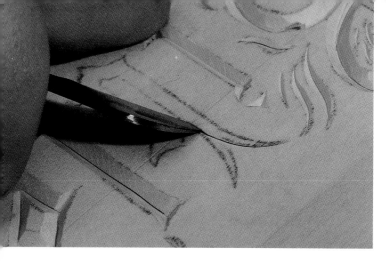 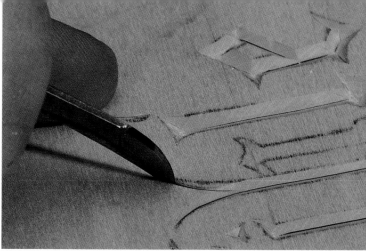

On the small "b", start at the point and come down the inside of the straight element.

Carve the other point cutting up to it on the inside...

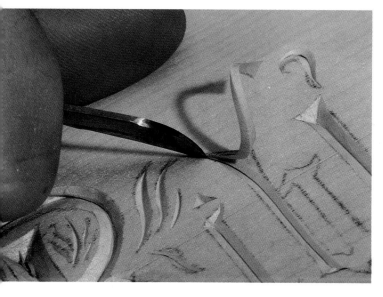 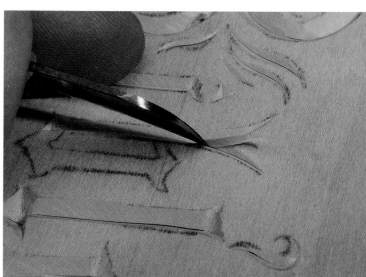

Come up the other side.

and down from it on the outside.

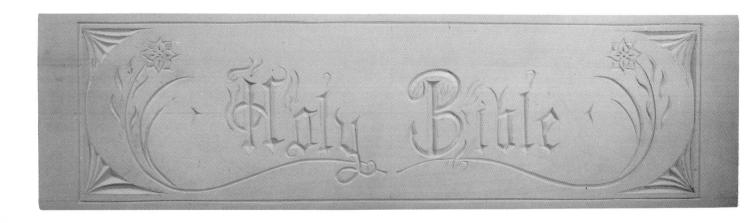

With the lines incised the front is complete.

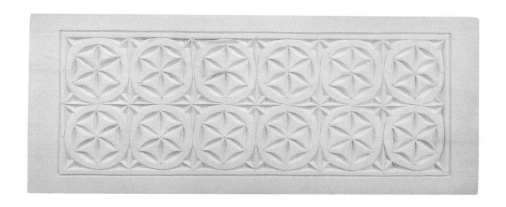

The side finished.

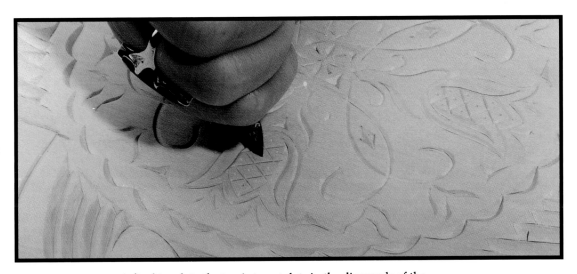

A final touch to the top is to put dots in the diamonds of the tulips with a nailset.

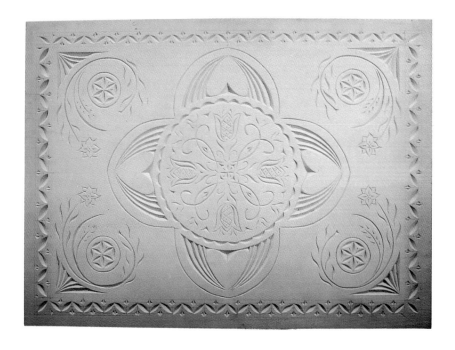

The top complete.

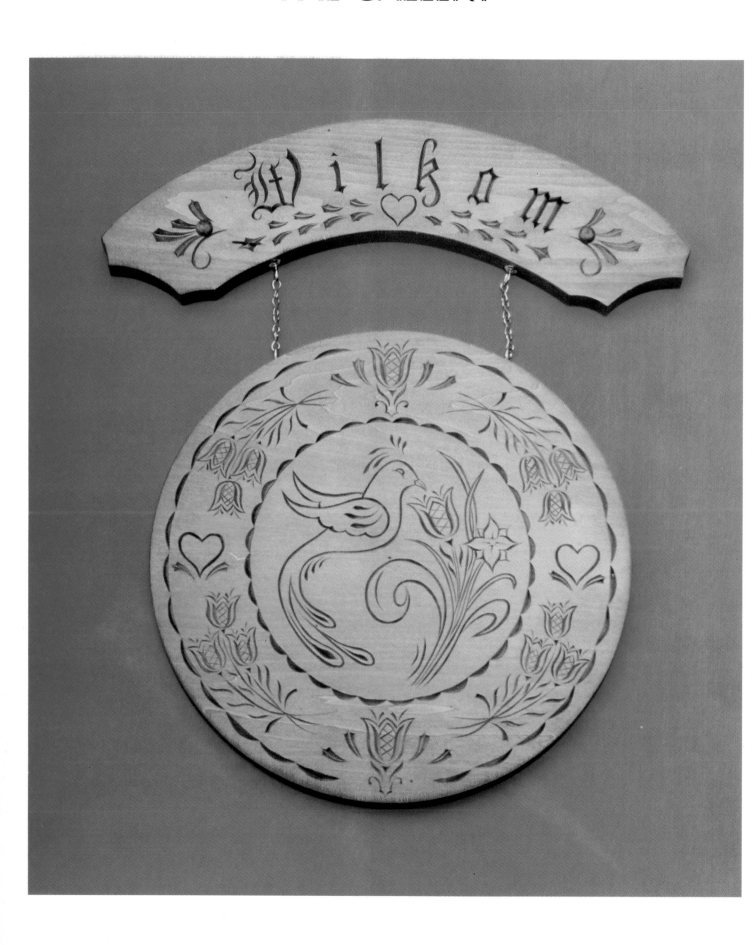

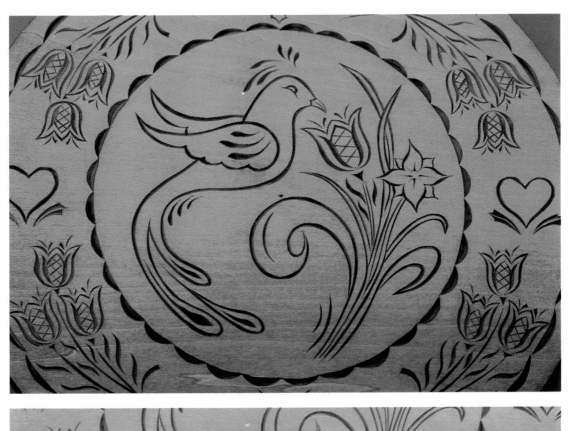

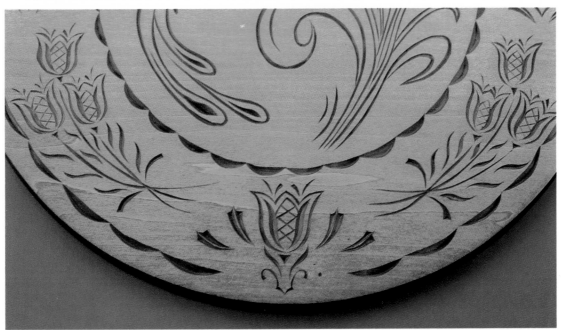

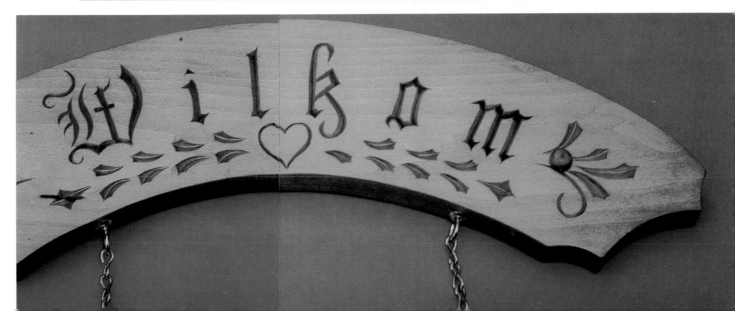

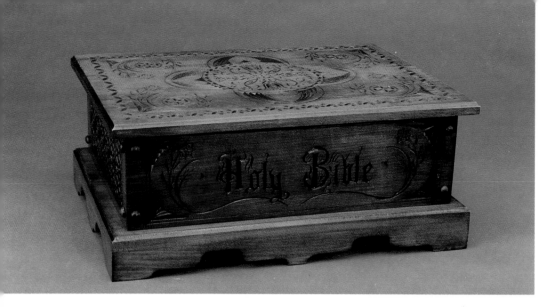

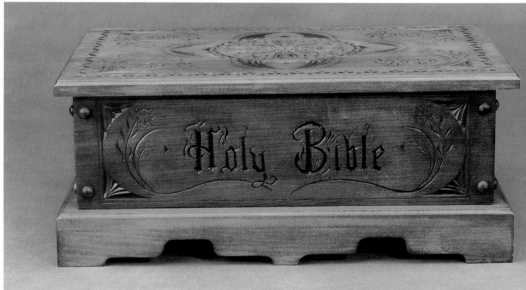

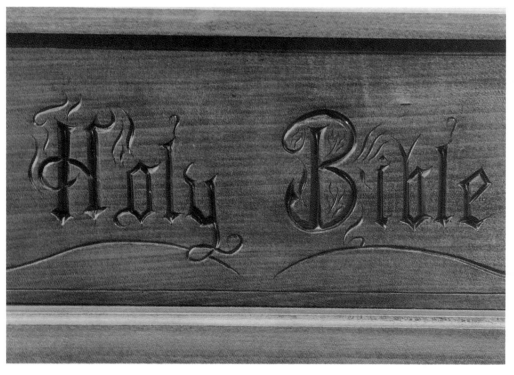

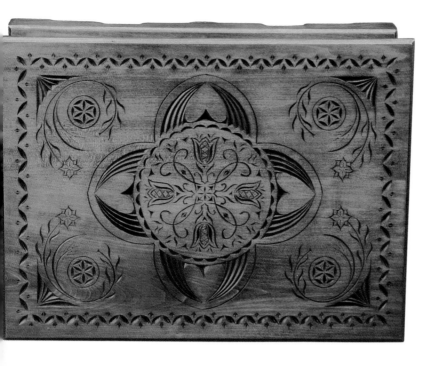

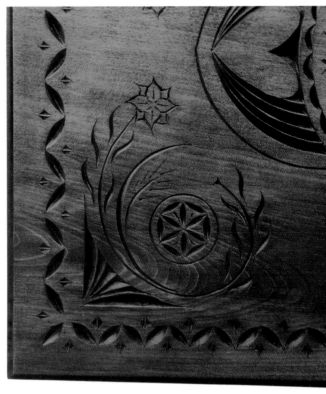

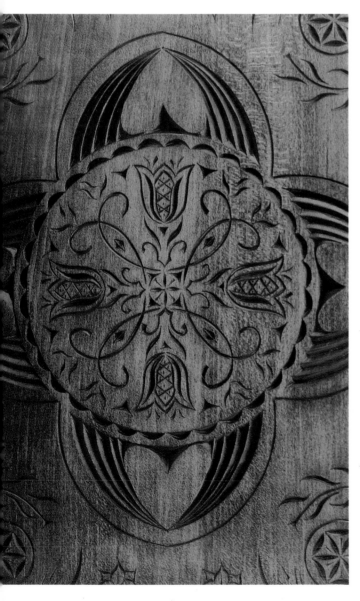

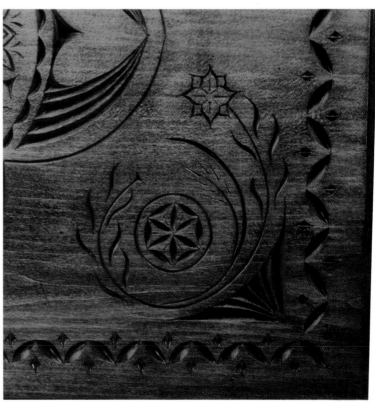

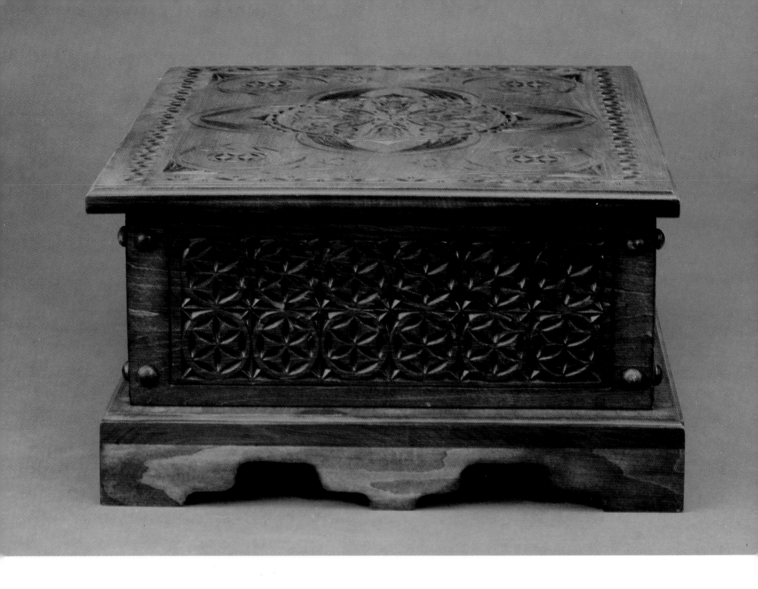

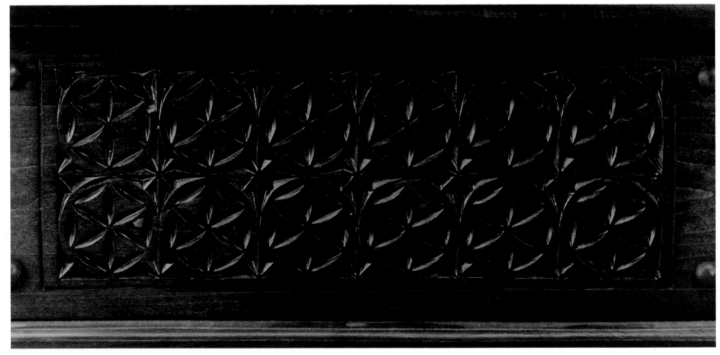

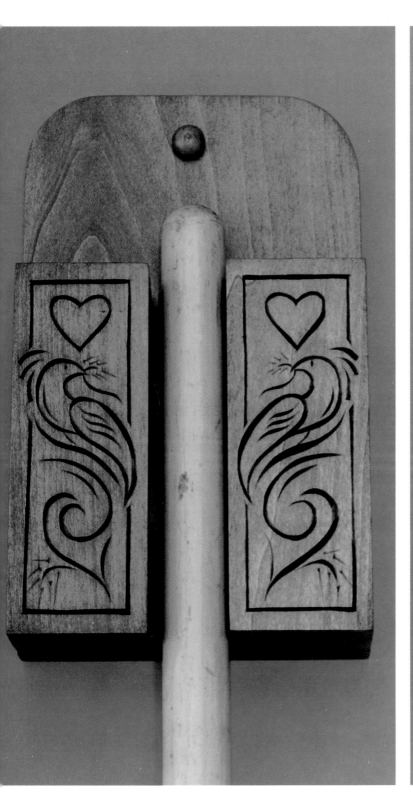 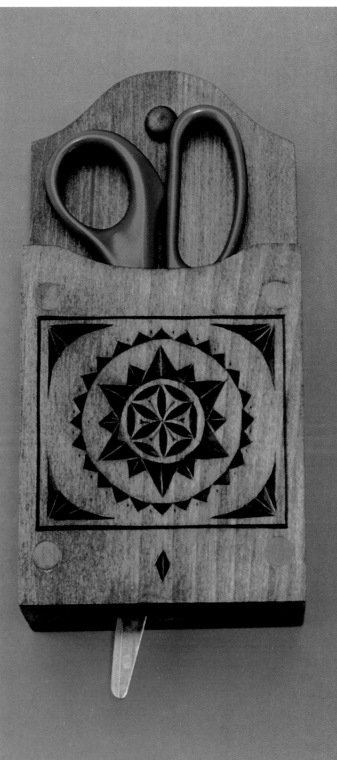

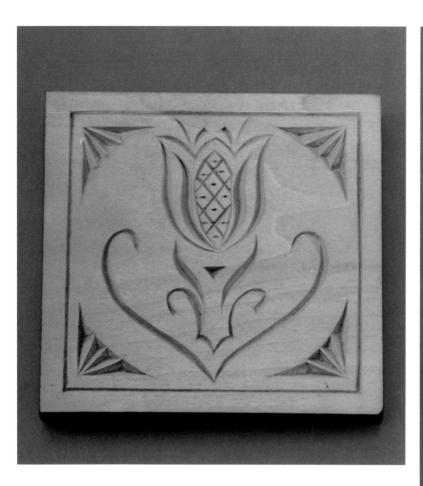

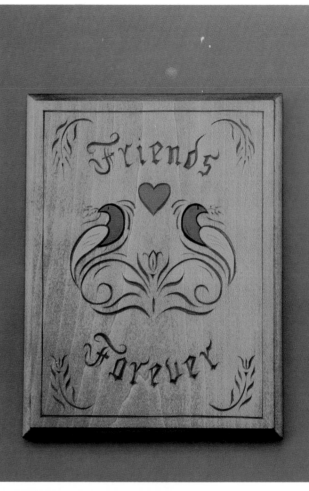

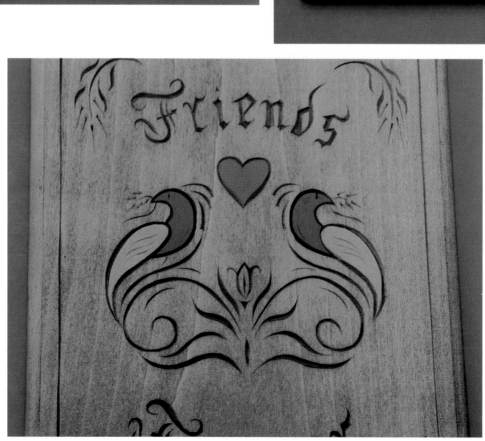

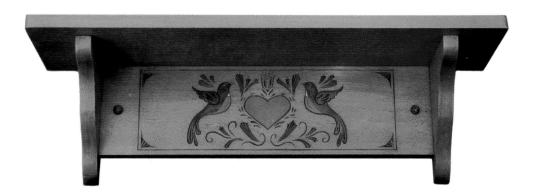

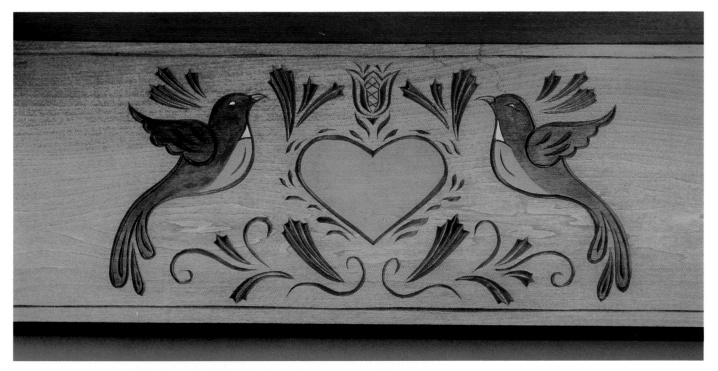

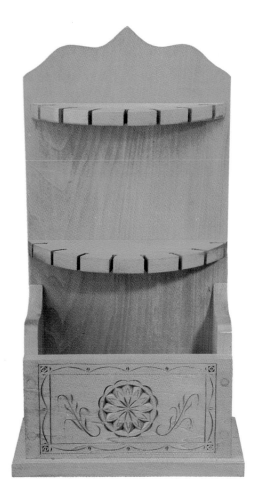

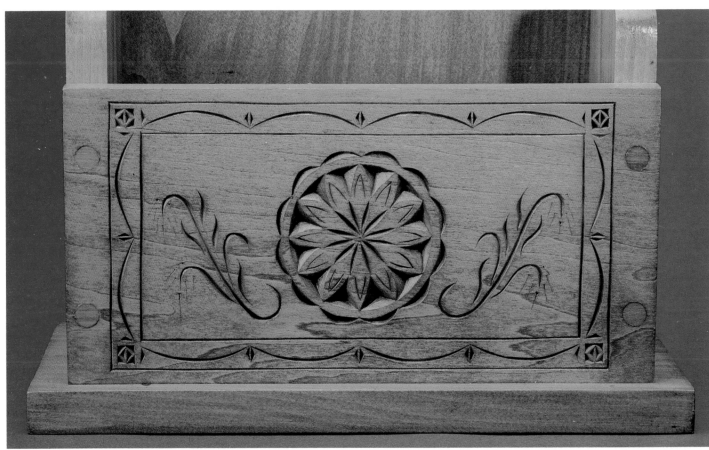